70s Fashion Fiascos

STUDIO 54 TO SATURDAY NIGHT FEVER:
Your guide to the funky, flashy looks
of the 1970s, where disco never dies
and denim never fades.

Maureen Valdes Marsh

PORTLAND, OREGON

For my mother Shirlee and her purple velvet shoes;
my father Richard, who gave me his humor;
and my husband Barry, who puts up with it all.

Interior Design: Kevin A. Welsch, Devon Smith, Collectors Press, Inc.
Cover Design: Lisa M. Douglass
Editors: Lindsay Brown, Collectors Press, Inc., Ann Gosch

Library of Congress Cataloging-in-Publication Data
Valdes Marsh, Maureen
 70s fashion fiascos : Studio 54 to Saturday Night Fever / by Maureen

Valdes Marsh. -- 1st America ed.
 p. cm.
 Includes bibliographical references.
 ISBN 1-933112-26-3 (softcover : alk. paper)
 1. Clothing and dress--United States--History--20th century. 2.
Fashion--United States--History--20th century. I. Title. II. Title:
Seventies fashion fiascos. III. Title: Studio 54 to Saturday Night Fever.
 GT615.V35 2006
 391.0097309'04--dc22
 2006011758
Distributed by Publishers Group West

First American Edition
ISBN 10: 1-933112-26-3
ISBN 13: 978-1-933112-26-8

Printed in Malaysia
9 8 7 6 5 4 3 2 1

Collectors Press books are available at special discounts for bulk purchases, premiums, and promotions. Special editions, including personalized inserts or covers, and corporate logos can be printed in quantity for special purposes. For further information contact: Special Sales, Collectors Press, Inc., P.O. Box 230986, Portland, OR 97281. Toll free: 800.423.1848.

For a free catalog call toll free: 800.423.1848 or visit collectorspress.com.

CONTENTS

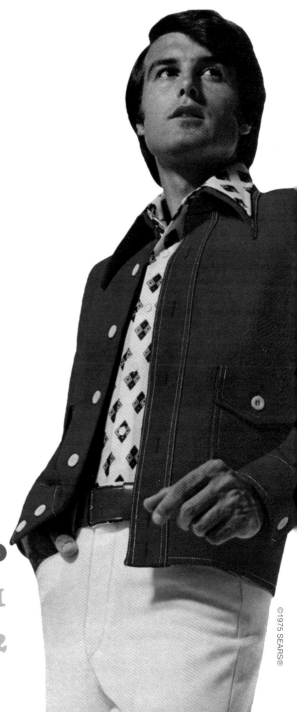

INTRODUCTION

In between the free love of Woodstock '69 and the 1980 death of John Lennon lay a decade that would come to be remembered not only for its historical events—the shootings at Kent State, the end of the Vietnam War, Three Mile Island and Love Canal, Watergate and the resignation of a president—but also for its pop culture.

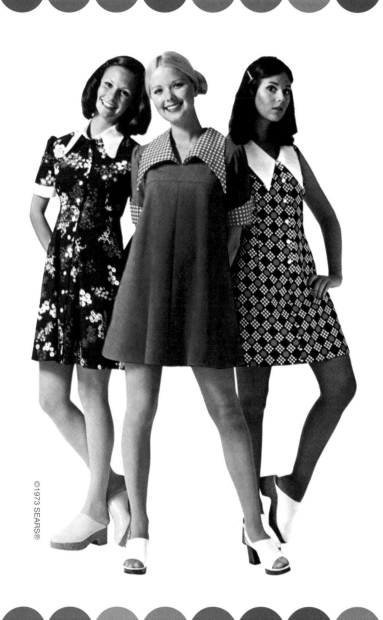

©1973 SEARS®

1970s pop culture wasn't simply about the excesses of Studio 54 or the squeaky-clean images emanating from the *Donny and Marie* TV show. The true pop culture of America lived in the day-to-day world of suburbia. As suburbanites, we showed our tender, compassionate side by how we tended and pampered our Pet Rocks. We showed our tolerant side by the patience we exhibited while waiting in endless gas lines. We showed our exuberant nature by the fervor with which we bumped and hustled on the disco floor. But perhaps the biggest and most lasting slice of 1970s pop culture was in the clothes we wore.

Free from the constraints of the 1950s and peppered with the newfound spirit of the 1960s, fashion in the 1970s took on a life all its own. Flamboyance was no longer reserved for the young, rich, or famous. Flamboyant urbanity took a short ride over to suburbia's neighborhood, where it was welcomed with open arms.

Married and single women alike, energized by the passions of 1960s youth, began to open their eyes and ears to the awakening world around them. The women's liberation movement, which had begun the decade before, blossomed and flourished in the 1970s as more and more women left the shelter of their husbands' shadows and entered the workforce (and world)— many for the first time in their adult lives.

The peace demonstrations, protest marches, and rallies for equality spurred women to ask why they were relegated to the roles of teacher, nurse, secretary, or dutiful wife. For years someone else had told them how to think, how to dress, and how to act. Suddenly women were asking for and receiving choices, both in the workforce and in how they dressed. The white gloves were off at last—literally!

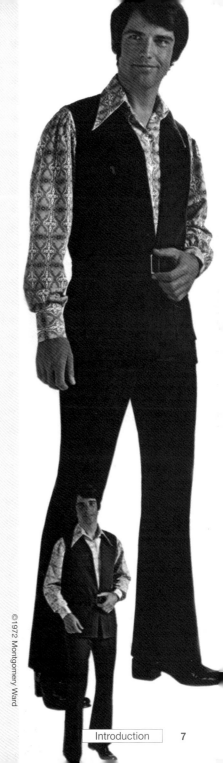

©1972 Montgomery Ward

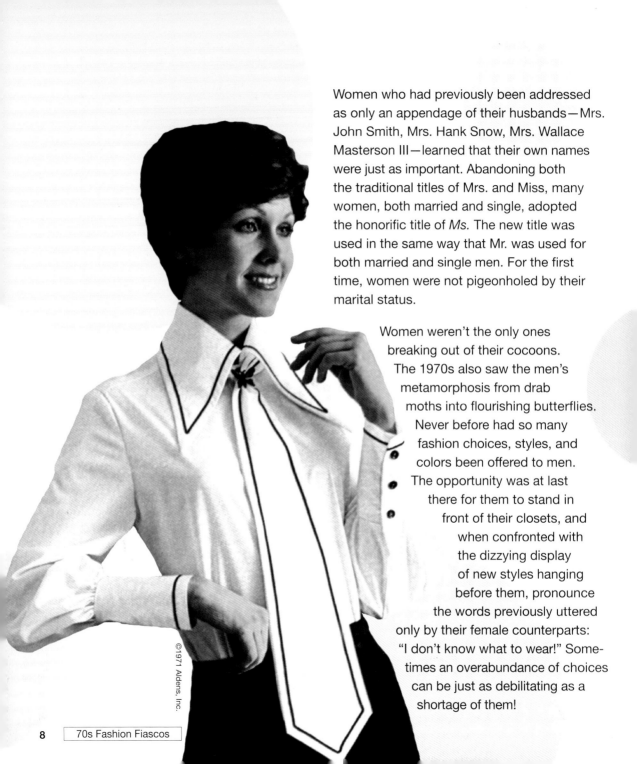

Women who had previously been addressed as only an appendage of their husbands—Mrs. John Smith, Mrs. Hank Snow, Mrs. Wallace Masterson III—learned that their own names were just as important. Abandoning both the traditional titles of Mrs. and Miss, many women, both married and single, adopted the honorific title of *Ms.* The new title was used in the same way that Mr. was used for both married and single men. For the first time, women were not pigeonholed by their marital status.

Women weren't the only ones breaking out of their cocoons. The 1970s also saw the men's metamorphosis from drab moths into flourishing butterflies. Never before had so many fashion choices, styles, and colors been offered to men. The opportunity was at last there for them to stand in front of their closets, and when confronted with the dizzying display of new styles hanging before them, pronounce the words previously uttered only by their female counterparts: "I don't know what to wear!" Sometimes an overabundance of choices can be just as debilitating as a shortage of them!

©1971 Aldens, Inc.

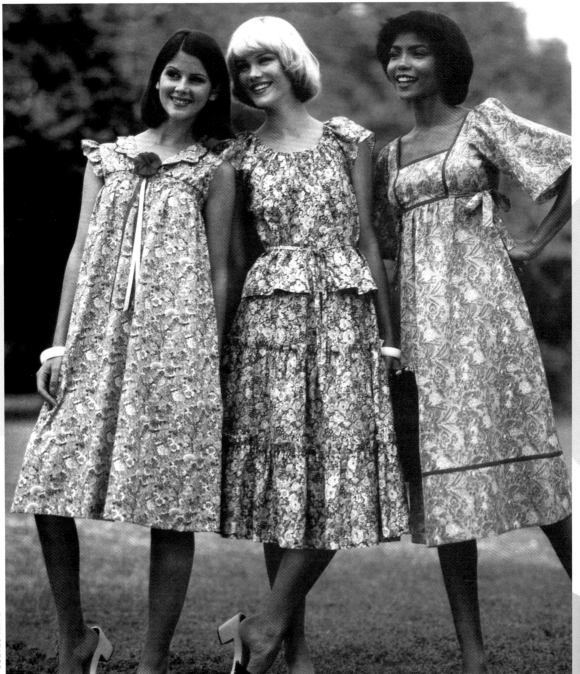

Often overshadowed by the women's movement was the just-as-pivotal men's liberation movement. Spurred on by the 1960s counterculture revolution and women's lib, men found themselves questioning the meaning of what a man was supposed to be. The tradition of centuries had dictated that a man was a rock, the solidifying strength of society. The new decade caused men to question that "do or die" role as the sexual revolution took hold. Men began to look at their roles as spouse, partner, provider, and leader. The gay movement released some from the constraints that had for so long restricted their lives. Others were free to explore child rearing as their wives entered the workforce in their place.

Both sexes participated in discussion groups to explore their current and future roles in society. Mass-produced and slickly marketed programs such as est (Erhard Seminars Training),

©1972 Aldens, Inc.

which was based in existential psychotherapy and Zen Buddhism among other things, sprung up promoting responsibility through structured exercises and techniques. By 1978, est had more than 170,000 graduates; and the program, founded by Werner Erhard (born John Paul "Jack" Rosenberg), had grossed more than $9 million.

The fashion industry felt the rumbles that the newfound movements created. By the time the 1970s began, the old

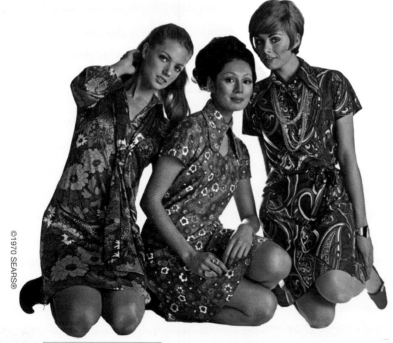

©1970 SEARS®

tradition of *haute couture* custom clothing was fast becoming but a memory. Major department stores closed their custom salons as people began to dictate their fashion wants to designers, instead of designers dictating to the masses. It became a survival-of-the-fittest time for designers, who found the need to package and market themselves, rather than their designs. The key was to make their name, rather than their fashions, the status symbol.

One of the most successful examples of this trend happened in the late 1970s when Jordache launched its line of skin-tight jeans and placed its logo on the backside. Its success prompted others to quickly follow suit. Designers like Sergio Valente, Sasson, and Gloria Vanderbilt joined the rush to have their label displayed on the posterior. But it is perhaps Calvin Klein who is best remembered for his designer jeans, all thanks to the steamy advertising that placed a young supermodel named Brooke Shields into a pair, while she whispered to the masses, "Know what comes between me and my Calvins? Nothing."

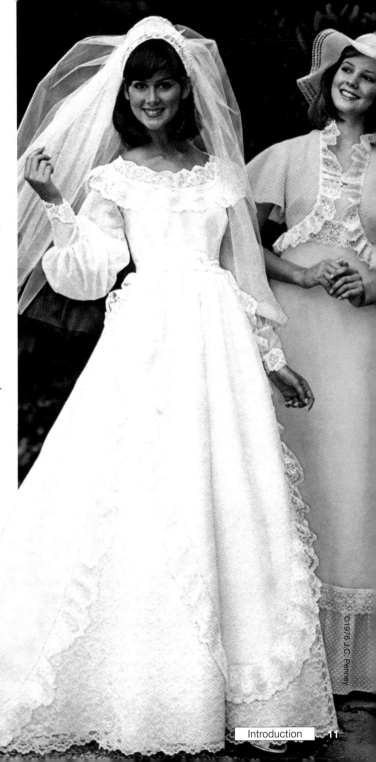

©1976 J.C. Penney

The 1970s felt its share of fashion influence from the giant silver screen of Hollywood. The movie *Saturday Night Fever* brought out fashions reserved for the disco club scene and popularized them for the rest of the waiting world. Grossing $282 million worldwide, *Saturday Night Fever* sparked a mad craze for anything disco, most notably the infamous white polyester suit sported by the film's star, John Travolta, during the pivotal dance competition scene. In addition to the film's influence, the fashions were further propelled by the music. The Bee Gees, who provided the soundtrack, were renowned for their satin baseball jackets and skintight pants.

It wasn't just disco music that influenced many of the fashions in the 1970s. Long before the movie *Grease* was a hit at the box office, singer Olivia Newton-John's gorgeous down-to-earth looks and immense popularity had her paving a fashion path with styles as diverse as long prairie dresses, pretty floral-print sun dresses, and satin jumpsuits. And British designer Ossie Clark was responsible for dressing some of the rock scene's most influential players of the time: Mick Jagger, Jimi Hendrix, Marianne Faithfull, and super-models Twiggy and Jean Shrimpton.

©1971 Aldens, Inc.

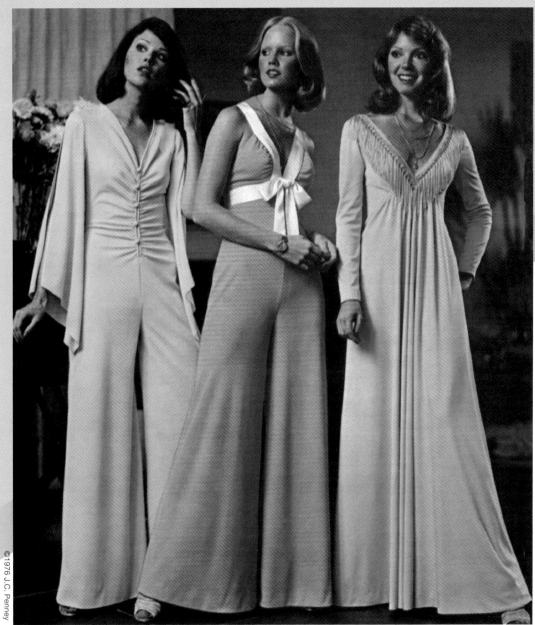

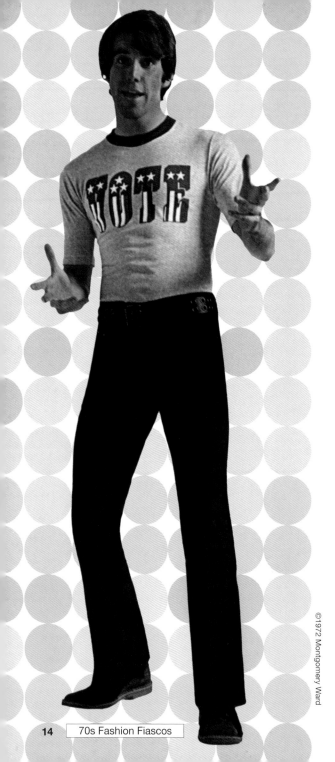

The small screen did its best to inspire fashion trends as well. The TV show *The Partridge Family* is directly responsible for a line of girls' pantsuits styled after the fashions worn by characters Shirley and Laurie Partridge. *Starsky & Hutch* launched a craze for Cowichan cardigan sweaters, today commonly referred to as "Starsky Sweaters." (The original Starsky sweater was donated by the Starsky actor, Paul Michael Glaser, to the Pediatric AIDS Foundation and was auctioned off on eBay for $3,400 in 2000.) And who can forget the stampede caused by *Charlie's Angels* that had women rushing to their beauty salons in search of the feathery hairdo sported by actress Farrah Fawcett-Majors.

One style that took the phrase "making a fashion statement" and made it literal was the message T-shirt rage of the 1970s. T-shirts, once nothing more than undergarments, could now be found on people of every age, shape, and size. But not just any old T-shirts. These were walking billboards of self-expression. They proclaimed such messages as "I'm a virgin! (This is a very old T-shirt.)," "Be alert—this country needs more lerts," "It takes a virile man to love a liberated woman," "Make Love Not War," and of course everyone's favorite, "I'm with stupid."

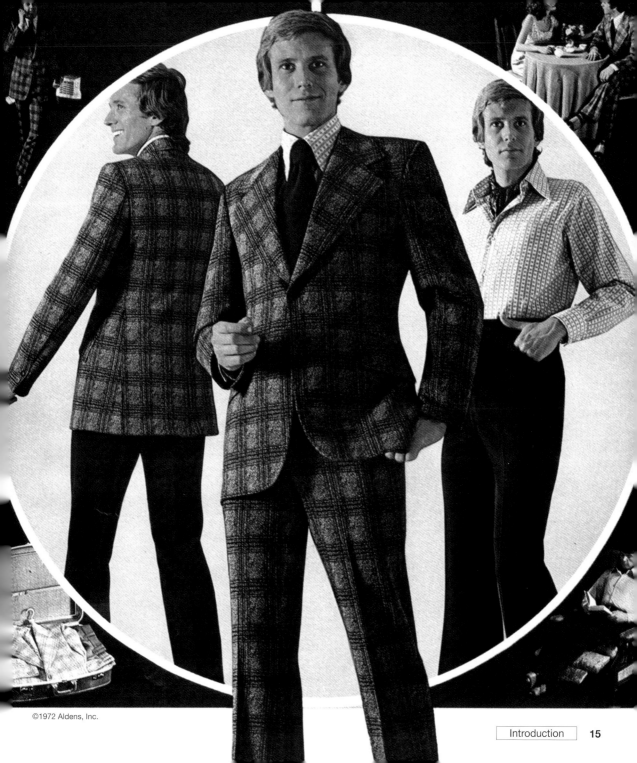

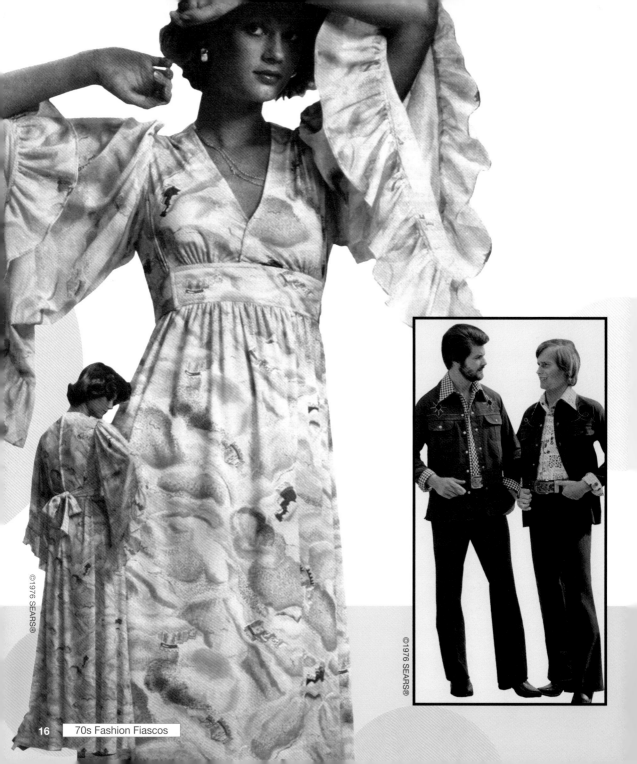

Just as the vast changes to 1970s culture had arisen, though, so did they fall. The fashions we now so closely associate with the era began to lose their staying power. Polyester garments were cast aside for a return to natural fibers. Women set aside their maxi granny dresses in exchange for tailored suits. Men replaced their loud, garish, wild-print shirts with muted earth tones and subtle patterns. The necktie reinvented itself once again, with the ultra-wide, 4-inch accessory replaced by narrower, more manageable swaths. Sky-high platform shoes were brought back down to earth in the form of comfortable flats. And all those millions of polyester leisure suits? Well, they were shuttled off to the Salvation Army, to await a time when, thirty years later, a new generation would rediscover disco, funk, and *That '70s Show*.

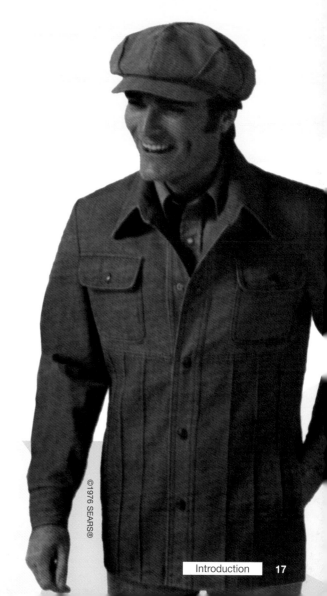

©1976 SEARS®

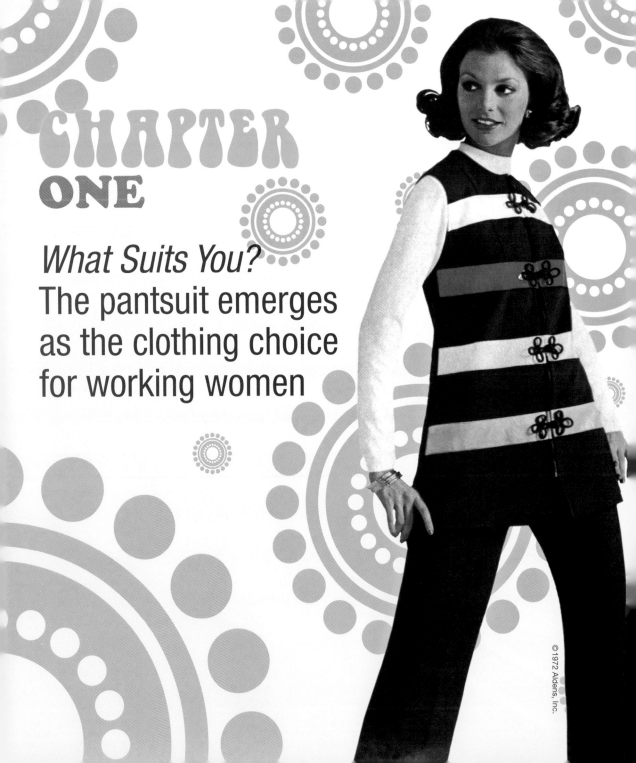

CHAPTER ONE

What Suits You?
The pantsuit emerges
as the clothing choice
for working women

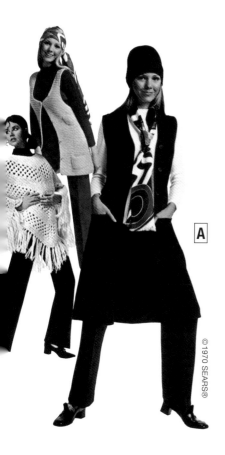

Chances are that when you put your clothes on in the morning, you'll be pulling on a pair of pants. But what if you weren't allowed to wear those pants? What if society deemed them to be unsuitable attire? Well then, congratulations! You've just transformed from a modern individual into a woman burdened with societal constraints: You are a woman living in the year 1970.

It's hard to think of something as simple as a pair of pants as a symbol of anything other than what it is—a garment made to cover your lower body. But in 1970, the wearing of pants and pantsuits was almost as controversial as showing up naked for work. The pantsuit was a symbol—a symbol that a woman was free to act and dress as she chose—even if it wasn't welcomed by many.

For years, pants were considered to be acceptable only for the missus to wear while performing her housewifely duties—cooking, cleaning, and grocery shopping. The rebellious youth of the 1960s helped popularize pants as an everyday garment by breaking the unwritten dress code of their predecessors. Thanks to the younger generation's quest for individuality and freedom of expression, pants became an important ingredient in the mix of a woman's wardrobe—at least for evening wear.

© 1970 SEARS®

A

A Many people felt pants were young and spirited. Others saw them as the breakdown of a ladylike appearance, even fearing they would lead to slouching and lackadaisical habits due to their casual aura.

In the late 1960s, fashion's autocratic leaders already knew that pants and pantsuits would be more than a passing fad for the next decade. Yet few of them presented pantsuits as anything other than evening wear. It wasn't until the calendar flipped to 1970 that America's mature set—that is, women over 25—began to realize that freedom of dress didn't belong just to the dark of night or to youth. If young women could wear pants in broad daylight, and men could wear pants in broad daylight, why couldn't they?

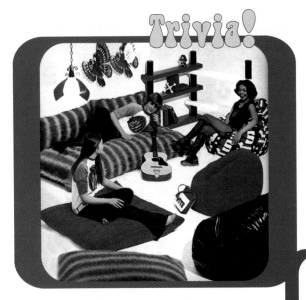

Trivia!

What kid didn't have a squishy, oversized floor cushion known as the beanbag chair? And what kid didn't secretly take great delight in watching a parent struggle to get out of it?

A Whether you were going to work or joining the Navy, this whimsical fashion ensemble was smartly tailored and contained all the key elements that were popular: wide, pointed collar, a vest, and of course, pants.

B Not all 1970 pantsuits were made out of garish polyester. Many, like this elegant outfit, were made of soft and breathable natural fibers such as wool or cotton.

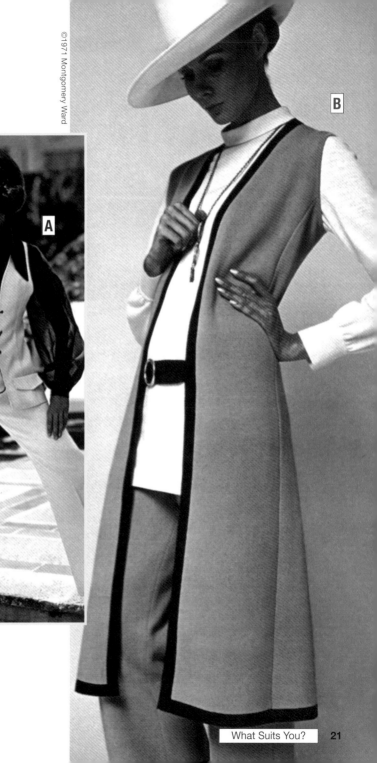

A

B

© 1970 Montgomery Ward

A Lengthy Controversy

As pantsuits slowly crept their way out of the closet door, another controversy was looming, one whose subject couldn't be skirted: hemlines.

Hemlines. Hemlines. Hemlines. They were up. They were down. They were planted firmly in middle ground. The battle of the hemline was waged from the fashion pulpits of Paris, Rome, and New York. Designers lined up and placed their bets on the hemline roulette wheel. Just where would they land? It was a dizzying display that kept fashion watchers watching and fashion writers writing. And the manufacturing industry? It just kept sweating and waiting for the roulette ball to drop.

Meanwhile, in homes across America, far away from fashion's elite, women had other ideas. They too were placing bets—but not on the merry-go-round of hemlines. They were laying their money down on the pantsuit.

Women wanted the pantsuit, and American retailers were all too happy to oblige. Suburban strongholds like Sears®, J.C. Penney, and Montgomery Ward were quick to stock their stores and catalogs with the new icon of liberation. So there you were: a liberated woman of the 1970s in your new pantsuit. Now, just where did you think you were going to wear it?

© 1971 Montgomery Ward

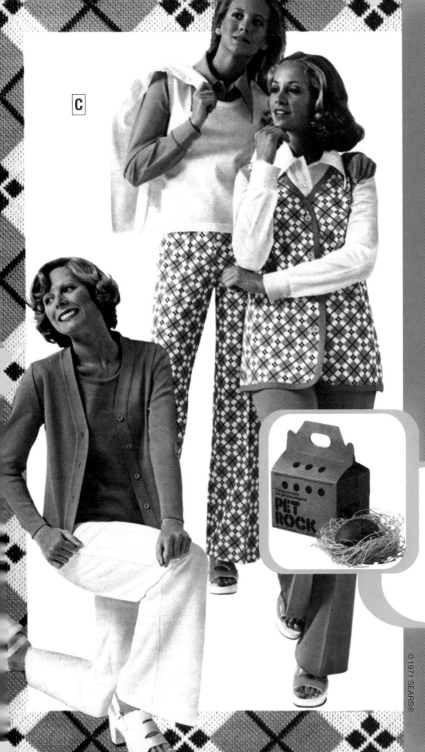

C

A With a collar that also doubles as an extra sail on stormy seas, this nautically influenced pantsuit is crisp, clean, and ready to rock the boat. On today's vintage market, the tunic-length, A-line top would be a hot seller as a summer frock.

B Crushed velvet: soft, romantic, and always a favorite for date wear or as an attractive sofa fabric. It was the 1970s, and the possibilities were endless.

C While American women snatched up pantsuits by the droves, Europeans clung to the notion of couture. Some were simply aghast that American women were no longer as careful with their clothes closets as they were their kitchen closets, to which American women replied, 'vive la révolution.'

Trivia!

In 1975 the Pet Rock proved that with the right marketing, people will buy anything. Consisting of nothing more than a lump of rock placed inside a miniature cardboard carrier, entrepreneur Gary Dahl sold 1.2 million at four bucks a pop. Somewhere a caveman is still kicking himself for the missed opportunity.

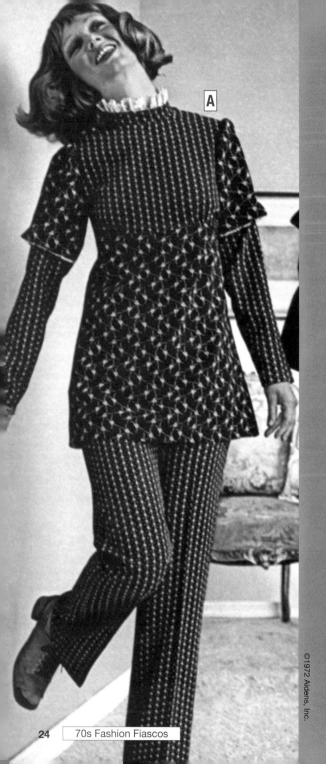

Pants—In or Out

If you thought you were going to wear your new pantsuit to the office, you were wrong. But at least your daughter could wear hers to school, right? Wrong! How about for a family outing to a "classy" place, like, say, the Santa Anita racetrack? You lose again! You might have won the battle of the hemline by choosing the pantsuit, but then you were up against an even bigger opponent—dress codes.

As women everywhere were denied the right to wear pantsuits where they liked, including to work and school, small rebellions in the form of a sit-in (called a "pants-in" at the time) were taking place. When 35 girls from a Massachusetts high school weren't allowed into classes because they were wearing pants and pantsuits, they held a pants-in in the school's driveway. At the CBS Broadcast Center in New York, workers found a memo from the manager of news administration on several of the department's bulletin boards:

> *Please be advised that it is not Company Policy nor the discretion of the immediate supervisor for female employees to wear slacks during the course of their normal working hours.... Slacks may be worn going to and from the Broadcast Center in the morning and evening, and/or on a lunch hour, business, or personal errand.*

Seven days later, 30 female employees from various CBS offices across Manhattan held a pants-in. They protested what they considered to be a form of sex discrimination by their employer.

A **kicky** (kick•y) *adj.*, *Slang.*, **-ier**, **-i·est**. So unusual or unconventional in character or nature as to provide a thrill. *The American Heritage Dictionary*

B Little girls shared in the phenomenon by donning pantsuits of miniature proportions. This young lady's costume is strikingly similar to that worn by members of the 1970s singing sensation *The Partridge Family*. C'mon, get happy!

C In the 1970s, some people still referred to their outfits as "costumes"—and in some cases it's easy to see why. The clothing often took on a theatrical appearance, such as this pantsuit, which could have easily been a part of a production of *Robin Hood* or *Peter Pan*.

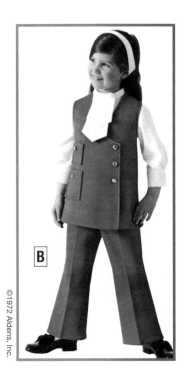

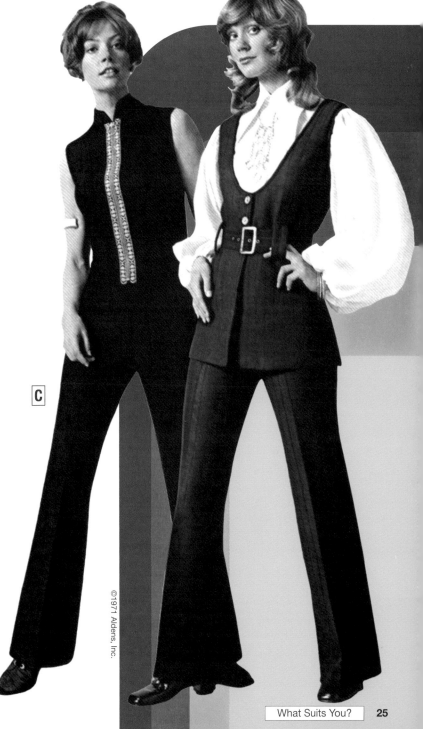

Love Your Pants? Thank a Nurse

When you think of nurses, you probably don't think "fashion forerunner." Yet in 1970, that's exactly what they were. As their miniskirted uniforms rose, their arduous daily tasks became increasingly more difficult. The bending, lifting, and reaching in their daily routines became a guarded ballet to prevent patients from viewing more than just compassion. The pantsuit solved that dilemma.

At Queen of Angels Hospital in Southern California, a group of seven nurses petitioned for a change of uniform—and it was granted. The news made page-one coverage across the nation, and other hospitals quickly followed suit. The crisp, white pantsuit uniform gave nurses the ability to operate in their often fast-paced environment without giving a second thought to how they would retrieve a dropped item from under a patient's bed (much to the dismay of some male patients and doctors). The trend was set in motion, and for nurses and other women everywhere, there was no looking back.

©1971 Montgomery Ward

A Fashion critics advised against wearing a pantsuit if you were a size 14 or larger. Their reason? It accentuated your ample figure flaws. In the early 1970s, a size 14 woman measured 36″-27″-37.5″. That modern size equivalent? A mere size 8.

B Girl Power, 1970s style:
Flippy 'do? ✓
Personality with spunk and sass? ✓
Pink pantsuit packed with attitude? ✓✓
You go girl!

B

Trivia!

The bodysuit was a cleverly designed one-piece garment whose purpose was to maintain a sleek fit through the torso. Unfortunately, it proved embarrassing if the wearer couldn't manipulate the crotch snaps in the disco restroom after consuming too many drinks.

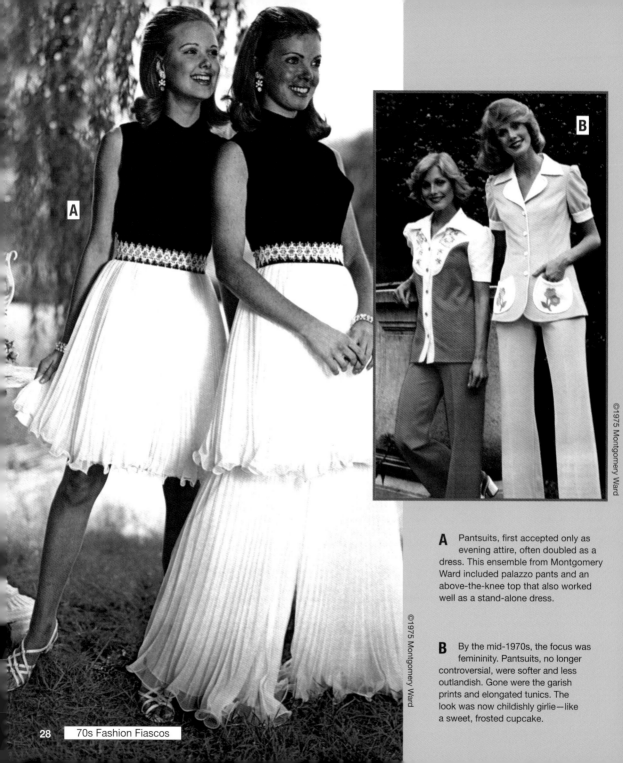

A

B

©1975 Montgomery Ward

©1975 Montgomery Ward

A Pantsuits, first accepted only as evening attire, often doubled as a dress. This ensemble from Montgomery Ward included palazzo pants and an above-the-knee top that also worked well as a stand-alone dress.

B By the mid-1970s, the focus was femininity. Pantsuits, no longer controversial, were softer and less outlandish. Gone were the garish prints and elongated tunics. The look was now childishly girlie—like a sweet, frosted cupcake.

A Matter of Choice

As dress codes changed, women experienced their newfound freedom with relish. For apparel retailers and manufacturers, the new fashion trend was like pennies from heaven. The pantsuit helped revive sagging clothing sales and kept manufacturing employees busy. But what was really won was the right to choose—and choose women did.

Some women chose pants; others chose to keep with their traditional mode of dress. When 35-year-old Barbara Walters, then of NBC's *Today* show, was asked her opinion on the current trend, she said, "I just don't feel like a fashion leader. When your show is nationwide, you have to be a little conservative. I would never wear pants suits on the air, for example. I think the show has more dignity than that." And that was okay, because it was all about choice.

By the end of the decade, the pantsuit moved from a controversial garment to an everyday staple. The restrictions once banning pants for women were gone and, for the most part, forgotten. The garment that had once caused groups to gather, petitions to be written, and women to question their rights is now just another choice in the closet. But for the women who lived through the experience, the memory of wearing pants to the office for the first time still remains a point of great pride. It was the first time they could stand next to a man and be considered an equal. They were no longer differentiated solely because of the garment they wore.

Ladies in pants, we salute you.

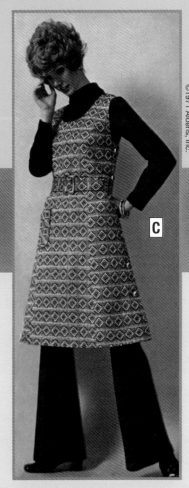

C Pants were often disguised under enough yardage that they were barely noticeable. Some saw these as a way to ease into the new fashion movement without standing out too far from the norm.

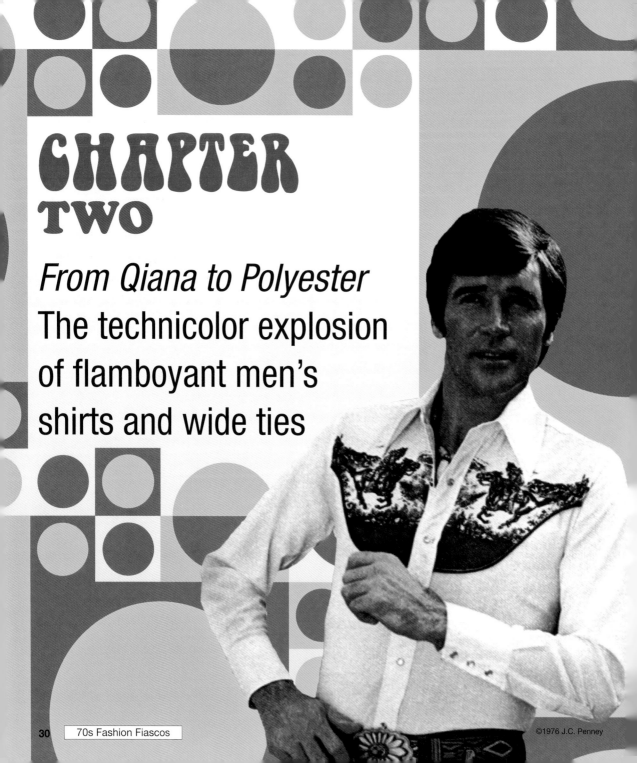

CHAPTER TWO

From Qiana to Polyester
The technicolor explosion of flamboyant men's shirts and wide ties

70s Fashion Fiascos

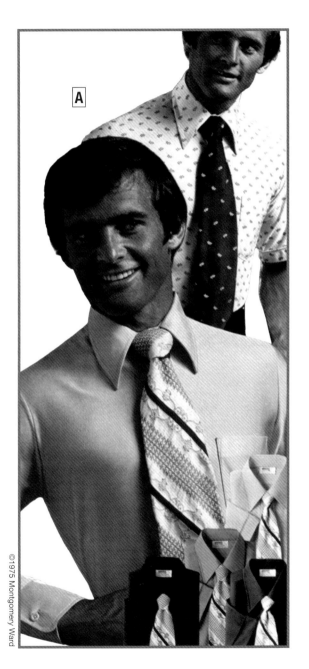

Children are always told, "Don't judge a book by its cover." The same could have been said of men and their clothes—until the 1970s, that is. Before that time, most men, except for the youthful hippy culture, dressed alike—with little variety—day after day. There were no mass movements of change as there had been for women's garments. Men were stuck in a deep, dark rut. It's a wonder they didn't fall asleep just looking into their closets. Fashion for them was a bore, and then the 1970s came along.

A Taking fashion risks means never having to say you're sorry.

B Burt Reynolds' popularity was at such a peak in the 1970s that men everywhere emulated his suave style—from mustache all the way down to white bucks.

Bang the Drum Slowly

Call it a backlash from the women's liberation movement, call it designers seeking a new revenue source, or just call it fortuitous for men, but the fashion demigods rained down favorably on them in the 1970s, releasing them from the bonds of white, button-down collar shirts. What started out as a gradual change to something as simple as a blue button-down shirt in 1968 suddenly blossomed into more color and more flash than ever before. The white shirt was becoming an anomaly as business shirts suddenly appeared in colorful yet subtle stripes—even checks. The ball began to roll, and men liked it.

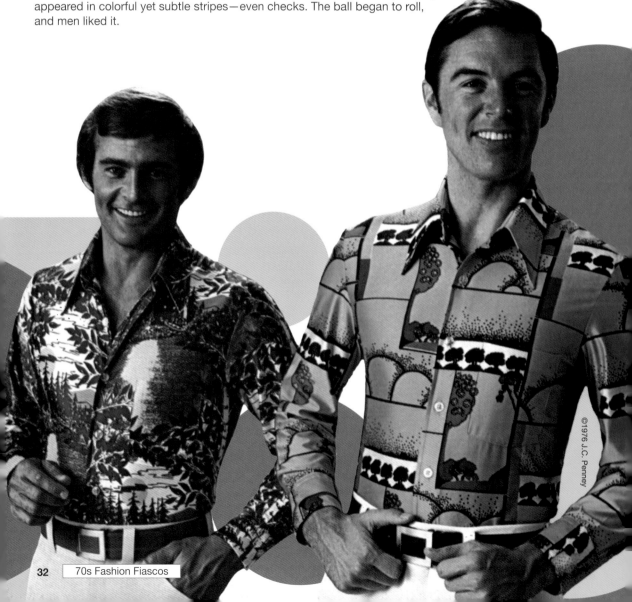

©1976 J.C. Penney

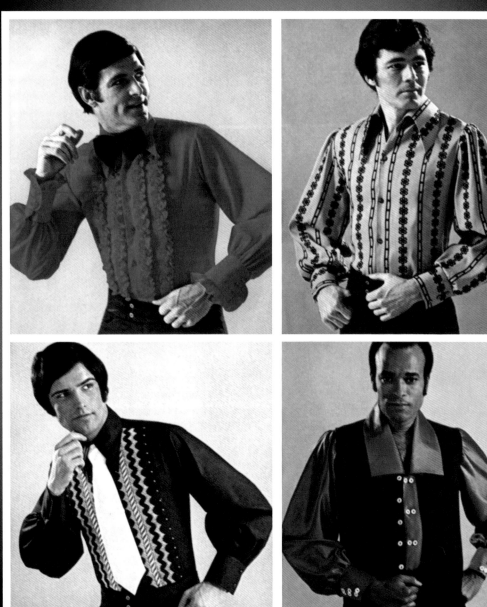

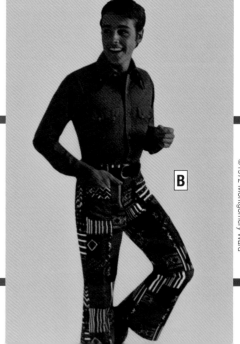

The Urban Peacock

Retailers soon found it hard to keep up with the demand for colorful terry cloths, lacy gauzes, boldly striped cottons, and even Italian laces—all coming from their men's departments. Male shoppers didn't hesitate to snap them up at a pace of 180 million a year in 1970, a 30 percent increase from the previous year. Retailers who had previously sold dress shirts at a mix of 80 percent white and 20 percent colored now saw that proportion reversed, with the colorful newcomer being the leader. Men, once relegated to a handful of white business shirts, found the need to increase their clothing budgets to accommodate the massive array that lay before them. The term "clothes horse" no longer applied solely to the mare. The stud farm was now full of stallions learning the subtle ins and outs of coordinating shoes, shirts, and slacks.

A

B

©1971 Montgomery Ward

©1972 Montgomery Ward

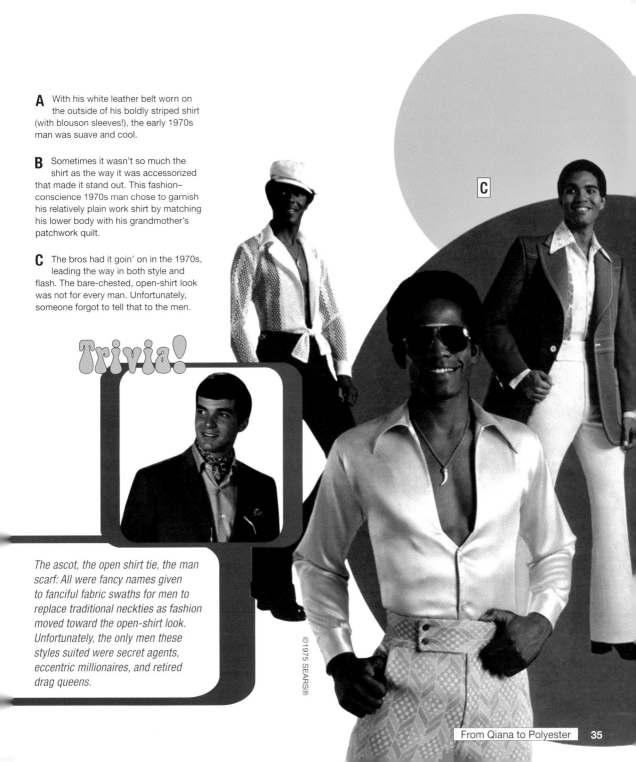

A With his white leather belt worn on the outside of his boldly striped shirt (with blouson sleeves!), the early 1970s man was suave and cool.

B Sometimes it wasn't so much the shirt as the way it was accessorized that made it stand out. This fashion–conscience 1970s man chose to garnish his relatively plain work shirt by matching his lower body with his grandmother's patchwork quilt.

C The bros had it goin' on in the 1970s, leading the way in both style and flash. The bare-chested, open-shirt look was not for every man. Unfortunately, someone forgot to tell that to the men.

C

Trivia!

The ascot, the open shirt tie, the man scarf: All were fancy names given to fanciful fabric swaths for men to replace traditional neckties as fashion moved toward the open-shirt look. Unfortunately, the only men these styles suited were secret agents, eccentric millionaires, and retired drag queens.

©1975 SEARS®

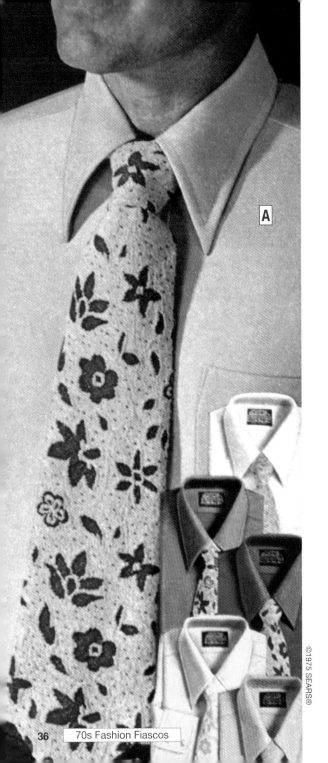

All Knotted Up

With men's dress and casual shirts transitioning from bland wallflower to preening peacock in mating season, the necktie became the odd man out. Accustomed to its place as the conservative man's noose, the tie found itself being reached for less and less as the open-collar look spread through the ranks. Men who used to suffer the bizarre ritual of wrapping a length of twisting and turning cloth tightly around their necks found the acceptance of the open-collar work shirt liberating.

Not willing to give up their share of the menswear market, tie makers did what any cunning quarter-back would do—they went wide. The introduction of wider lapels on suit and sport jackets brought with it the need to widen the conventional necktie to a new standard of four inches—and sometimes as wide as five inches. Bold stripes and patterns jumped off the triangle-pointed swaths. Famed pop artist Peter Max launched his own line of five-inch ties in abstract patterns of sunbursts, stars, and faces, among others.

The butterfly bow tie attempted to spread its colorful wings to attract younger wearers. One industry insider went so far as to proclaim the butterfly bow tie no mere fad but a significant fashion trend. But like the life of a real butterfly, this bow tie's was as short as its fashion-challenged cousins: the effeminate open-shirt tie, the ascot, and the man scarf. All were introduced as the next big thing. In fact, none were.

A Ties widened to an average of four-inches to keep pace with the wider lapels on men's sport coats. At the same time, fashion was moving away from the constricting accessory in favor of the open shirt.

B Polyester was a popular fabric for the ultra-wide 1970s tie. It was renowned for its ability to retain its shape wear after wear, not to mention its tremendous stain-fighting power.

©1975 SEARS®

The onset of men's plunging, hairy-chested neck-lines threatened the 300-year-old tie with extinction. Dismayed tie manufacturers watched sales drop from $1 billion in 1970 and 1971 to $830 million the following year. Desperate times called for desperate measures, so with sales dwindling, there was only one clear card left to play: the sex card.

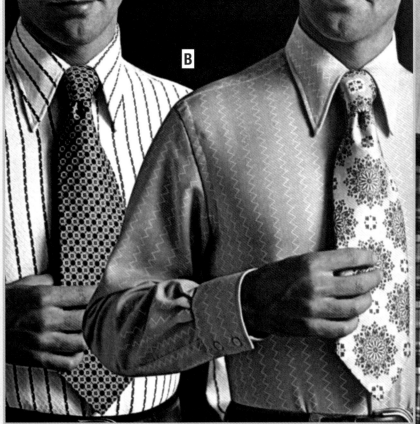

The Doctor Is In

As tie sales went limp, Dr. Joyce Brothers, popular talk show host, psychologist—and psychological fashion consultant for Trevira Fibres of New York—did a round of interviews discussing the sexual connotations of the necktie. Relying on studies and her own professional observations, Brothers declared to men that while they modestly covered up their naughty parts with clothing, they symbolically hung them around their necks via their phallic neckties. "And let's face it, a tie is a very intimate piece of apparel," she told them. "If you don't think so, have another woman straighten your tie in your wife's presence and see what happens. [Another woman] can dust the dandruff off your shoulder, but she'd better not touch the tie." That may explain one study conducted in 1970 that claimed men wore brighter and more colorful ties when they were interviewing new female secretaries than when they were meeting with another man.

Alas, contrary to popular opinion, sex doesn't always sell—at least it didn't help the necktie. Men continued to favor letting their chests do the talking instead of their ties. As the 1970s progressed, the open collar transformed into the all-out open shirt. It was perhaps Barry Gibb, of famed singing group the Bee Gees, who mastered this look to perfection. With a lion's mane of hair (both on his head and chest), Gibb and his brothers churned out thumping disco hits in high falsetto while remaining every bit male in spray-painted-on satin pants and bare chest laden with gold chains. It was a look oft repeated in discos coast to coast.

By 1978, tie sales were at a meager $750 million a year, down $250 million from the beginning of the decade. Men's vivid sport shirts of Arnel, Qiana, and polyester were the clear winners. With these fabrics' dizzying array of colors, patterns, and imaginative prints, the fashion revolution for men was here to stay. There would be no retreat into the dark fashion closet. The canned look was gone and American men were choosing clothes to fit their self-image. They were shopping—and they loved it.

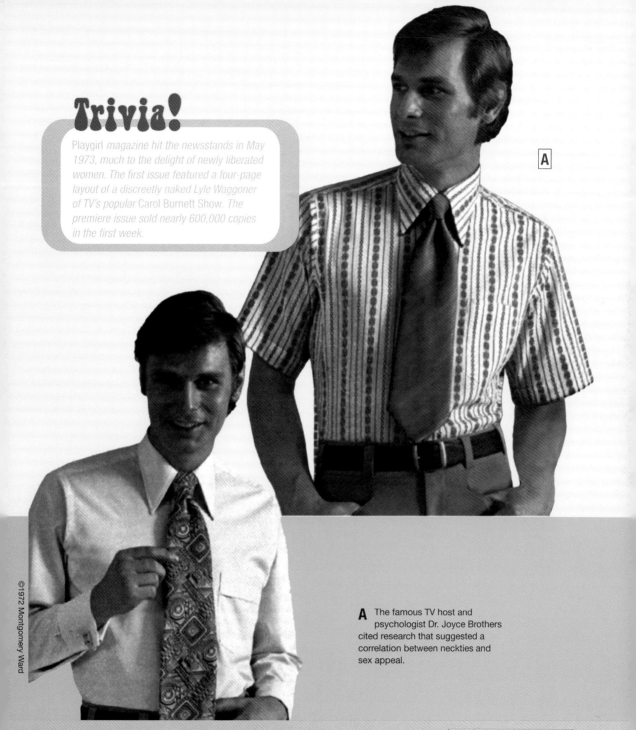

Trivia!

Playgirl *magazine hit the newsstands in May 1973, much to the delight of newly liberated women. The first issue featured a four-page layout of a discreetly naked Lyle Waggoner of TV's popular* Carol Burnett Show. *The premiere issue sold nearly 600,000 copies in the first week.*

A The famous TV host and psychologist Dr. Joyce Brothers cited research that suggested a correlation between neckties and sex appeal.

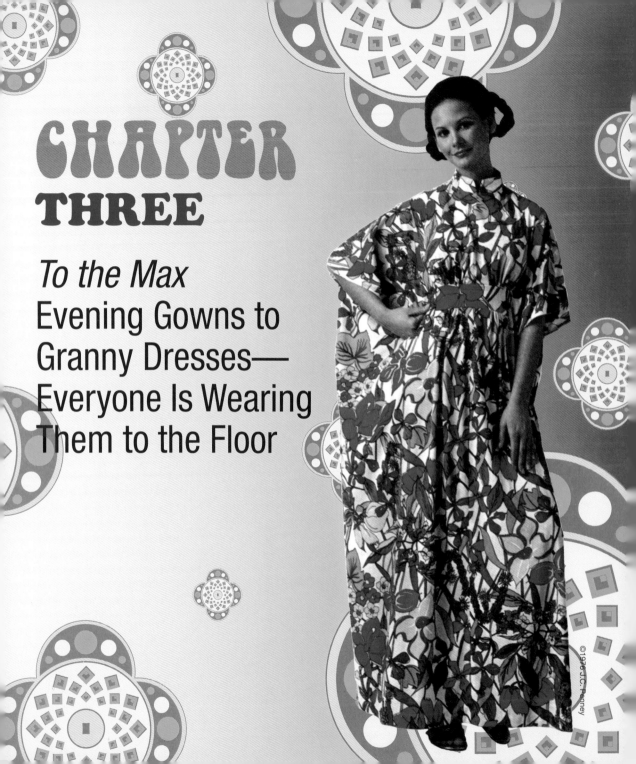

CHAPTER
THREE

To the Max
Evening Gowns to
Granny Dresses—
Everyone Is Wearing
Them to the Floor

©1976 J.C. Penney

When you look at the lack of choices women faced in the early 1970s, it's no wonder they became angry enough to burn their bras in protest. It seems in hindsight, however, that they were burning the wrong garment. Even though bra burning was a symbolic act of women's liberation, was it really the brassiere that was stifling women in the fashion sense? Or was it the overwhelming, in-your-face choices the fashion industry was rapidly throwing at them that made women strike the first match?

After years of being regulated to the same look, the same uniform Donna Reed–style apparel, the same rules of acceptable/unacceptable dress norms, women were now being overwhelmed by the choices laid out for them. It's something that we can't comprehend today. We are used to a society where individuality is the norm, freedom of choice the rule. But for a woman entering the 1970s, freedom of fashion choice created a kind of culture shock. It was like being a kid set loose in a candy store: At first you can't get enough; everything tastes sweet and delicious. But sooner than you'd imagine, your stomach (and your wallet) start to ache until at last you scream, "No more, please!"

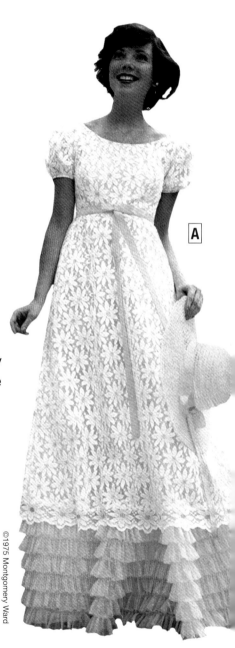

A

A Spring daisies and soft lace make this 1975 bridesmaid dress adorably sweet. The decade of the criminally offensive bridesmaid dress had not yet arrived. That would happen in the 1980s when taffeta made its resurgence.

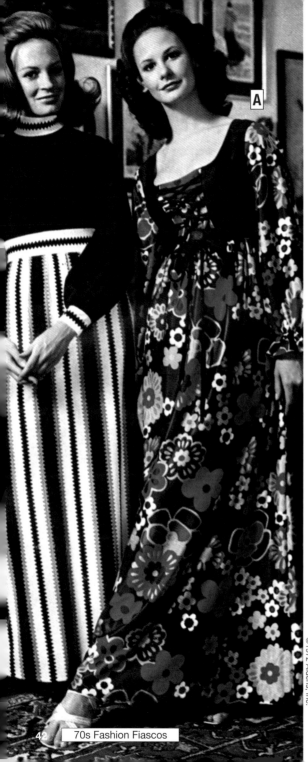

I've Got a Sweet Tooth For...

The "sweets" causing the aches in the 1970s fashion-frustrated woman were cylinders of fabric given tempting names: the mini, the micro mini, the classic mini, the midi (or to really tempt you, some called it the "longuette"), and the maxi. Each tasty treat was proclaimed by some sect of the fashion industry as *the* length or *the* "in" skirt. Yet one by one, each skirt's aching popularity decayed.

The first to fall was the mini skirt. Even the originator of the mini, designer Mary Quant, proclaimed its death and hailed the maxi skirt as *the* look. So what are you going to do? Some women formed small protest groups aimed at what they saw as the fashion industry's pressure to make the midi and the maxi skirt the front-runners. The industry hadn't yet heard that "doing your own thing" was now in.

The next to fall was the highly touted (and short-lived) midi skirt. Although the majority of designers, including Quant, were keen on the midi, women buyers were not. Most believed the midi was not only unflattering but actually added 10 years to their looks. Is it any wonder it flopped harder than the AMC Pacer! The only time in a woman's life she might actually yearn to look older is between the ages of 17 and 20—and then it's usually only to sneak into bars.

A This odd pairing of maxi dresses shows the sharp contrast between fashion-forward thinking and fashion resistance. One girl is alive with color and lightness while the other is still severely restricted by the immense weight of her 1960s helmet hair.

B By 1973, a distinct style change was starting to take place. Ginghams and country prints began softening the line of the maxi, giving it a down-home, *Little House on the Prairie* look.

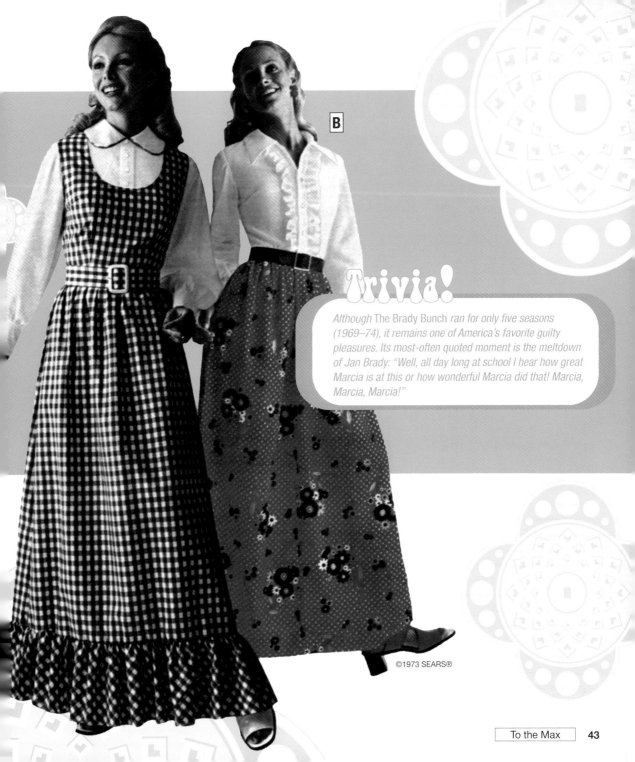

B

Trivia!

Although The Brady Bunch *ran for only five seasons (1969–74), it remains one of America's favorite guilty pleasures. Its most-often quoted moment is the meltdown of Jan Brady: "Well, all day long at school I hear how great Marcia is at this or how wonderful Marcia did that! Marcia, Marcia, Marcia!"*

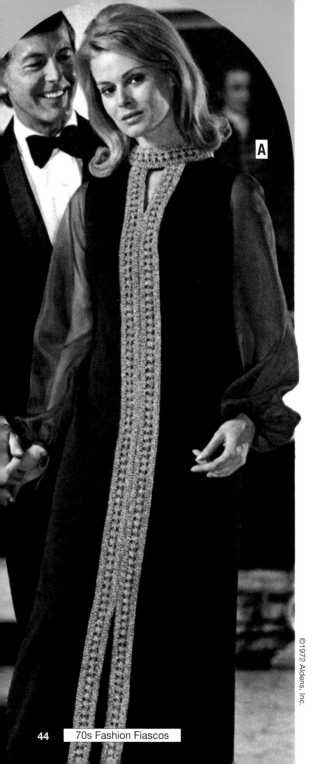

A

Grab a Granny

In 1970, fashion designer James Galanos was credited as the first American designer of significance to banish short skirts from his collection. As the decade crept along, the average hemline stabilized at just above or just below the knee. With the mini and midi effectively eliminated, the only contender in the hemline controversy still standing was the maxi—which, surprisingly, surpassed the mini in actual sales.

A style of maxi dress highly popular with teens and young women was the "granny" or "prairie" dress. Its freshness was a direct result of the down-to-earth fabrics and patterns in which it was offered. Among the most popular were cotton voiles, gingham checks, and dainty florals in peasant dresses with flourishing swirls of ruffles or lace. Their popularity brought about a change in how girls dressed, not just for everyday wear, but for important social events as well.

A Velvet was a favorite during the early part of the 1970s. It could be found on Aladdin-inspired evening gowns, ladies' pantsuits, and of course, countless couches throughout America.

B At the beginning of the 1970s, long dresses were still stiff and formal, looking more like wedding cake toppers than anything else. By the end of the decade, maxi dresses had evolved into more comfortable, relaxed garments.

C Prom dresses became less formal and more renaissance. Gauzy muslin and soft cotton voile give these prom dresses a shot at life after death—something that more formal dresses might not have the opportunity to experience.

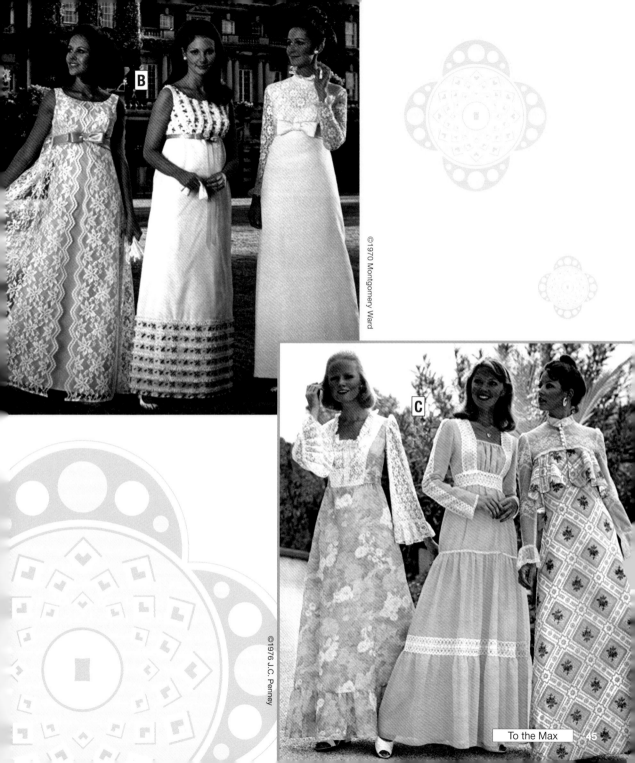

B

C

To the Max　45

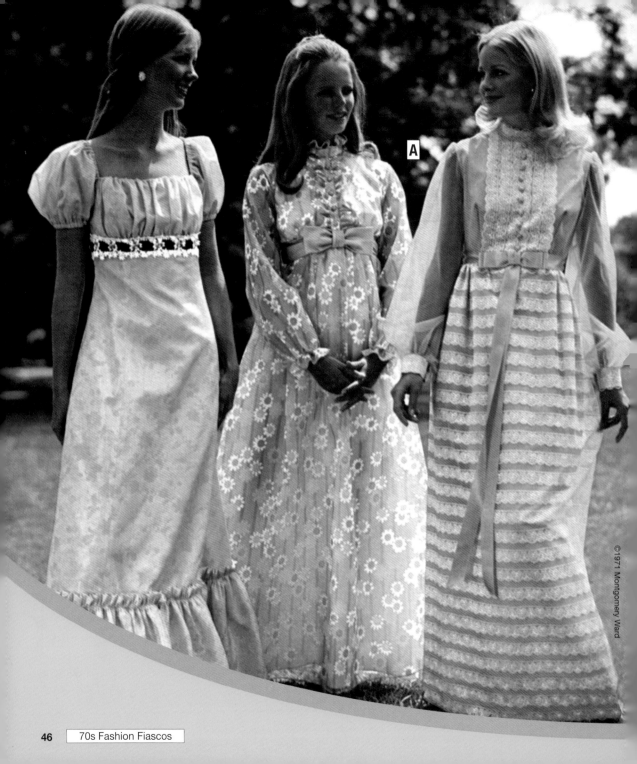

Peasants at the Prom?

High school proms (short for promenade) have been a part of American culture since the 1920s. The original proms were more an event for young people to hone their grooming, social, and dancing skills—all under the watchful tutelage of chaperones, of course. The introduction, or reintroduction (let's not forget our prairie-crossing ancestors), of the peasant or prairie dress brought about a relaxation of prom attire during the 1970s. Girls opted to forgo the stiff formals of the 1960s and reach for the soft femininity of the peasant dress instead. Parents liked the ease to the pocketbook, as prairie dresses could cost considerably less than traditional formal gowns. A teen could just as easily fall in love with a $38 prairie dress as she could a $120 formal. It also proved popular for her date. A less-formal girlfriend required a happily less-formal boyfriend.

For the parent whose daughter insisted on a "designer" maxi for the prom, retailer Montgomery Ward offered the ideal solution. Hiding behind the limited-collection label "Mr. E" was Spanish fashion designer Luis Estevez. Like Christian Dior with his "Monsieur X" label, Estevez brought high fashion down to the little people by designing a less expensive line. Still, the designs were of outstanding quality. His black-and-white-print Arnel jersey maxi dress featured a deep-V décolletage in the back and came with an appealing price tag of $38.

Trivia!

The scales of justice were tipped in favor of sex appeal for some of America's favorite 1970s crime fighters: Wonder Woman (Lynda Carter), The Bionic Woman (Lindsay Wagner), Police Woman (Angie Dickinson), and of course, Charlie's Angels (Farrah Fawcett, Kate Jackson, and Jaclyn Smith). You saw few prairie dresses on these gals!

B

©1971 Aldens, Inc.

A Junior party dresses, although less formal than two years earlier, still featured an overabundance of frills, ruffles, and bows.

B The "serving wench" look proved highly popular with young women wanting to show off their best assets.

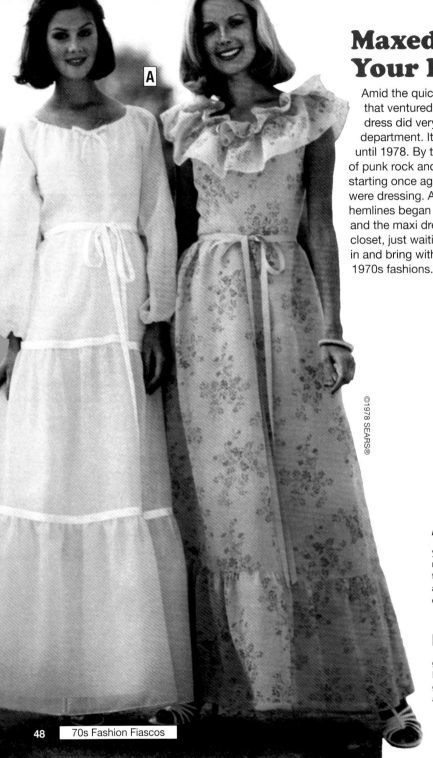

Maxed to Your Limit

Amid the quick-change-artist fashions that ventured through the 1970s, the maxi dress did very well in the staying-power department. It managed to remain popular until 1978. By then the emerging music genres of punk rock and new wave were moving in and starting once again to influence the way people were dressing. As the 1980s drew nearer, hemlines began to rise ever so slightly again, and the maxi dress found itself back in the closet, just waiting for the year 2000 to roll in and bring with it the yearning for "hip" 1970s fashions.

A Even though these lovely southern–belle–looking lasses were only two years away from 1980, their dresses gave no indication that they had any idea about the punk rock and new wave fashions about to hit them squarely between the eyes.

B Rickrack and smocking were popular finishes for teen dresses and tops, giving them a cute, individualistic look. Muslin fabric was a hit with every age group because it was so natural, easy, and appealing.

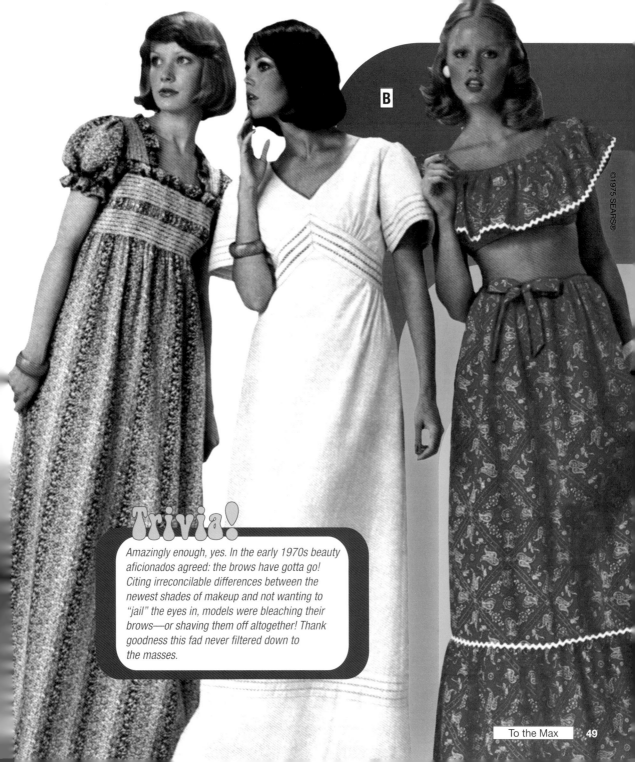

B

Trivia!

Amazingly enough, yes. In the early 1970s beauty aficionados agreed: the brows have gotta go! Citing irreconcilable differences between the newest shades of makeup and not wanting to "jail" the eyes in, models were bleaching their brows—or shaving them off altogether! Thank goodness this fad never filtered down to the masses.

CHAPTER FOUR

Mad for Plaid
Jackets, Suits, Pants—
Men Go Mad with
Plaid Fever

W hen we look back on the 1970s, is there anything that screams "nerd" more loudly than plaid? (Okay, there were those leisure suits, but most of us thought they were nerdy even during their heyday). Plaid seemed to cover everything from furniture to ladies' garments. But it was men's garments that it is most remembered for.

To be correct, what Americans refer to as plaid is what the Scottish traditionally call tartan. What the Scots refer to as plaid is actually a rectangular piece of cloth (yes, usually a tartan) that is worn in place of a cloak. Tartans or plaids have been around for centuries and are most commonly associated with Scottish kilts. Generally, each highland clan has its own tartan design, and the wearing of the tartan kilt remains a point of immense pride. That same plaid pride swept through 1970s America with a vengeance. No one was immune to plaid fever; it was just the thing to do, or risk being square.

A Plush pile coats were a big pleaser. Combined with a large masculine plaid and hot pimpin' hat, you've got a winning, stylish look that today's mack daddy would still love.

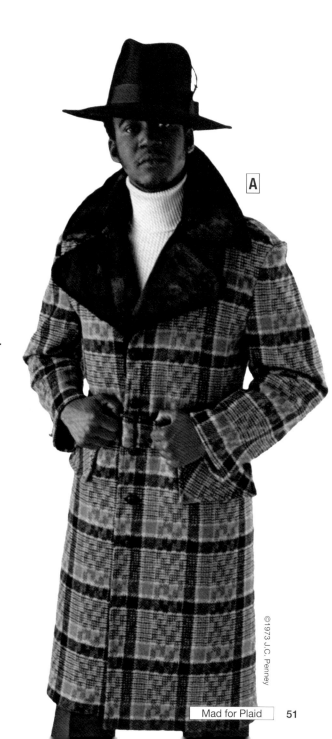

A

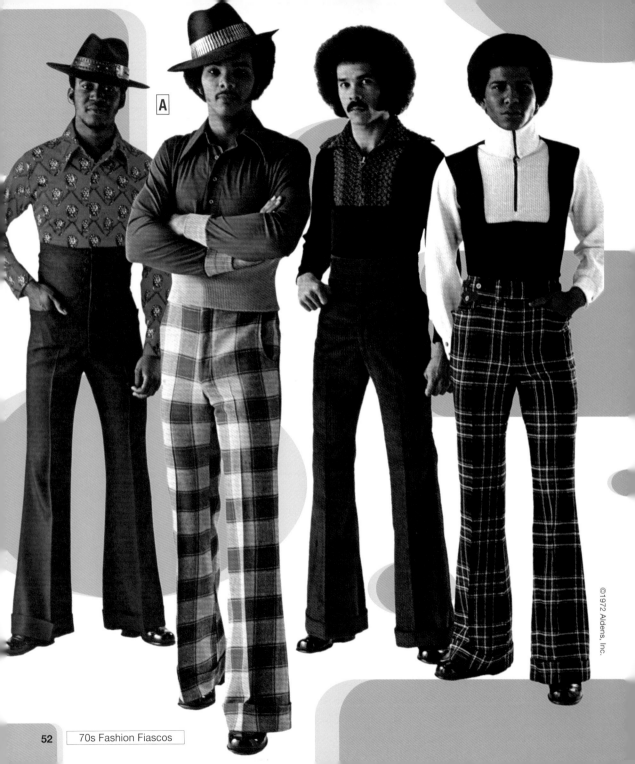

The Push for Plaid

Beginning early in the 1970s, plaid made its appearance in the design collections of Bill Blass, Anne Klein, and Norman Norell, just to name a few. It could be seen in men's slacks, jackets, shirts, hats, and even shoes. There was also a growing trend toward the use of horse-blanket plaids and checks galore—from large, lumberjack checks to miniature shadowed ones. Although the use of plaid fabrics for garments wasn't anything new to Americans, the explosion in the 1970s was above and beyond past trends. It was enormous—a decade made for squares in the literal sense of the word!

The plaids and checks favored by designers and manufacturers were not for the faint of heart. Fashions were being cut from a variety of showy fabrics in heart-stopping shades. Reds, yellows, greens, blues, and even pinks were as big, bold, and bright as they could be. Men were stepping out of the coop and strutting like empowered fashion peacocks.

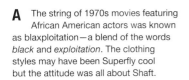

A The string of 1970s movies featuring African American actors was known as blaxploitation—a blend of the words *black* and *exploitation*. The clothing styles may have been Superfly cool but the attitude was all about Shaft.

B Pink plaid pants paired with a pink turtleneck was once considered a winning combination. Just why anyone thought it was perfect for adult men is anyone's guess!

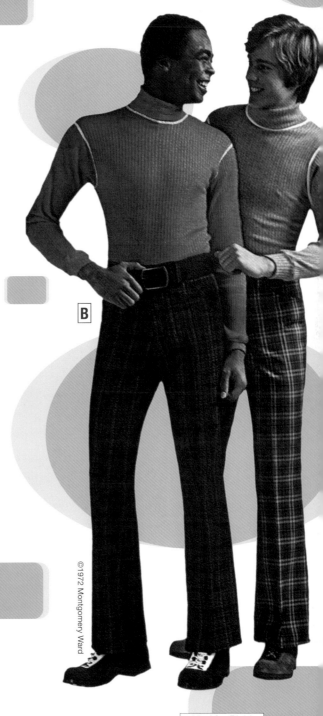

B

Fashionably Fore-ward

The plaid plague may have been a breakthrough in everyday fashion, but dressing in flamboyant plaids was nothing new on the golf course. Was it an example of life imitating art, or in this case, sports? For golfers, the world in the 1970s had turned into one giant clubhouse—and any avid player would tell you, that ain't so bad!

When discussing the flagrant use of flamboyant plaids, due credit must be given to the man who was single-handedly responsible for the rich pageantry of golf apparel that eventually seeped into men's everyday fashions. This man wasn't a fashion designer but golf's own three-time Masters champion Jimmy Demaret.

Demaret, best remembered as the all-time "character" of the PGA tour, had tired of golf's dreary attire and baggy outfits. Taking a handful of sketches to a New York tailor in the 1930s, Demaret asked for clothing made in a mind-numbing array of plaids and shocking pinks. The tailor protested, "But Jimmy, those are ladies' clothes!" Did that stop Demaret? Not a chance. Golf attire was never the same again.

A Checks and plaids were synonymous with style and class in the 1970s. Today these outrageous pants are a hot commodity for vintage sellers as the young gravitate toward the nerd look as a thing of pride.

B "Once you can accept the universe as being something expanding into an infinite nothing which is something, wearing stripes with plaid is easy."
—Albert Einstein

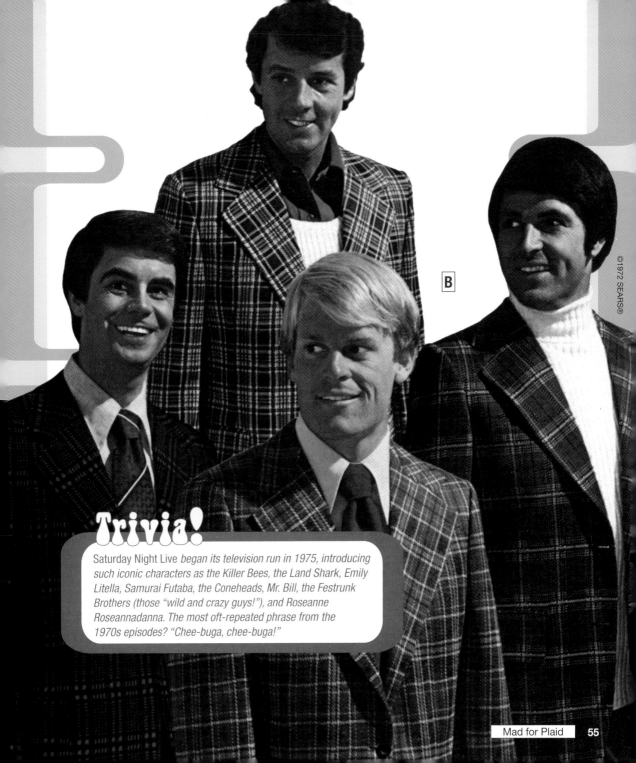

B

©1972 SEARS®

Trivia!

Saturday Night Live *began its television run in 1975, introducing such iconic characters as the Killer Bees, the Land Shark, Emily Litella, Samurai Futaba, the Coneheads, Mr. Bill, the Festrunk Brothers (those "wild and crazy guys!"), and Roseanne Roseannadanna. The most oft-repeated phrase from the 1970s episodes? "Chee-buga, chee-buga!"*

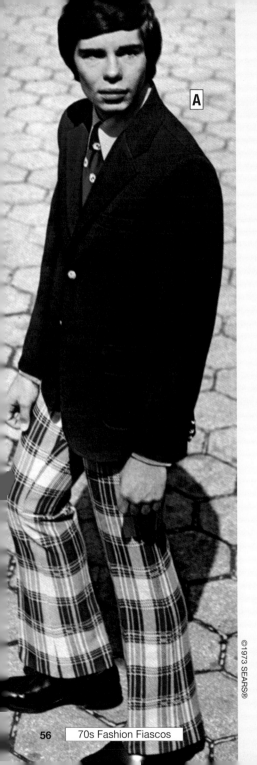

A

S-A-T-U-R-D-A-Y Night!

Plaid's next surge came in 1976 when the world was besieged by five young men who threw tartan's tenure into high gear. The Scottish bubblegum pop band The Bay City Rollers earned its trademark by donning tartan-trimmed garb while warbling a small repertoire of pop anthems, most notably the song "S-A-T-U-R-D-A-Y Night."

Heralded at the time as something close to 1960s Beatlemania, the Rollers' 15 minutes of fame actually lasted only five. But those five minutes did manage to bring plaid garments into the forefront of popularity once again. The colorfully lined and squared fabric was in demand, this time trimming the plackets, cuffs, and collars of jackets and shirts, and the cuffs of calf-length jeans. The craze snuck its way into manufacturers' lines and caused back-to-school fashions to reek of plaid. Normally upstanding clothiers, such as Bullocks, Lord & Taylor, Sears®, and Montgomery Ward, all found themselves hawking the wares.

Reveling in the short-lived glory, Rollers bassist Derek Longmuir quipped, "We think the whole thing is cute. I mean, it would make the whole world gorgeous if everyone dressed like us." The world, over the age of 15, disagreed.

Trivia!

> Western Airlines introduced the first male flight attendants in 1972. Although the three males graduated from the same stewardess school as their female counterparts, they were not required to attend makeup and hairstyling classes. They did, however, have to participate in "good grooming" sessions.

A Today we might snicker at this geeky fashion, but in the 1970s a pair of funky plaid pants, a tailored blazer, and a pink shirt was an outstanding collegiate look.

B Geeks and nerds often battle that the two are not the same. But there is only one thing the geek vs. nerd debate proved—that geeks and nerds are indeed cut from the same plaid cloth.

©1973 SEARS®

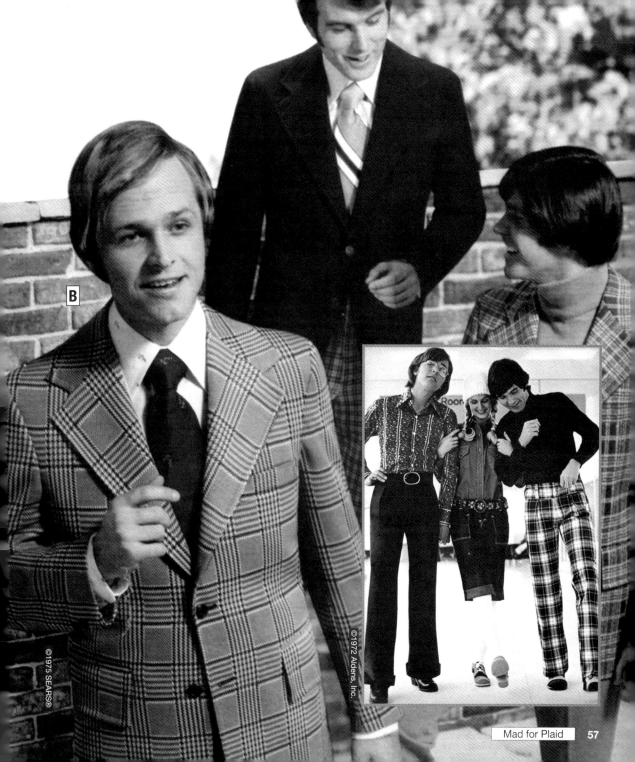

B

Mad for Plaid 57

In with a Bang, Out with Normalcy

By the end of the decade, plaid had run its course as the glaring catchall of fashion. Designers regained their senses and began using it proportionately. Instead of pairing it with garish hues, they softened it by mixing and matching pieces with complementary earth tones. Although its colors remained cheery, the plaid was approached with common sense and dignity—once again making the world safe for plaid lovers everywhere.

©1973 SEARS®

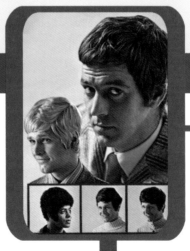

Trivia!

Following the advice of ads that proclaimed, "Let It All Hang Out…Soft and Swinging for $29.99," bald men raced to department stores and plunked down the bucks. With rug on the head and gold chains 'round the neck, they sidled up to the bar and in unison asked, "Hey, baby, what's your sign?"

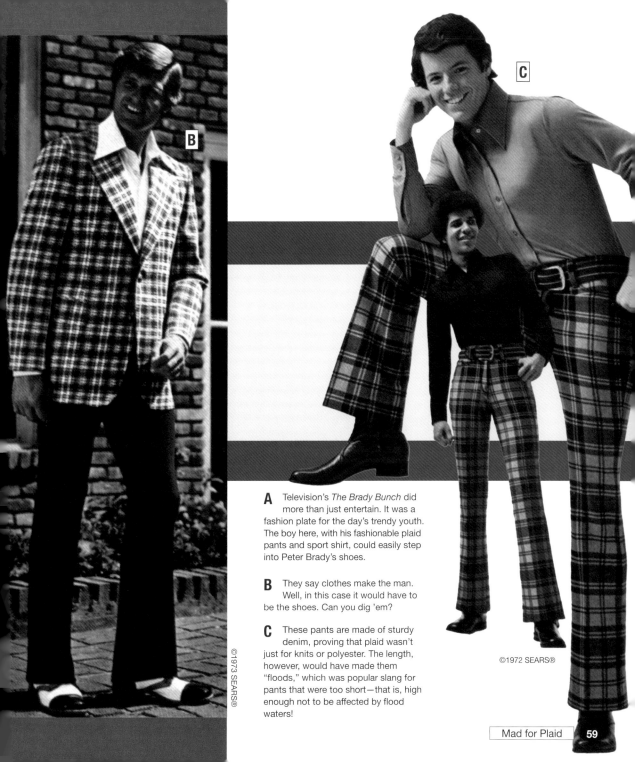

B

C

A Television's *The Brady Bunch* did more than just entertain. It was a fashion plate for the day's trendy youth. The boy here, with his fashionable plaid pants and sport shirt, could easily step into Peter Brady's shoes.

B They say clothes make the man. Well, in this case it would have to be the shoes. Can you dig 'em?

C These pants are made of sturdy denim, proving that plaid wasn't just for knits or polyester. The length, however, would have made them "floods," which was popular slang for pants that were too short—that is, high enough not to be affected by flood waters!

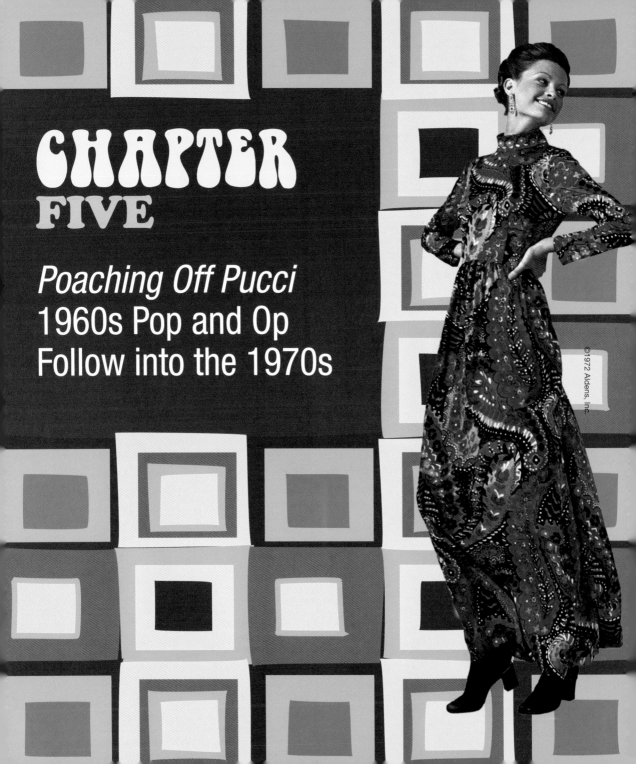

CHAPTER
FIVE

Poaching Off Pucci
1960s Pop and Op
Follow into the 1970s

ithin the newfound creative freedom of the 1960s and '70s, artists experimented, giving birth to two new genres of art that were drawn from a consciousness of the changing world around them. Yet somewhere between brush and canvas, the genres got crossed, and people began to look at them as one and the same.

The first on the scene was born from the postwar artwork heavily influenced by our quickly growing commercialism and unending materialistic hunger. In other words, we loved to spend money, and the corporate world was all too happy to prod us along. This popular art, or pop art as it became known, broke down the barriers between fine art and commercial art. The subjects of the pieces tended to be taken directly from the everyday world of advertising and celebrity. Andy Warhol and his vivid images of Marilyn Monroe or the Campbell Soup labels are perhaps pop art's poster children for the entire genre represented.

Pop art's first cousin was a movement that *Time* magazine termed "optical art" in 1964. Optical art, better known as op art, was illusion. Standing and looking at the pieces, the viewer could almost feel the lines and space moving, as if the artwork were alive and breathing. Although this method of art was pioneered in the late 1930s by artist Victor Vasarely, it is artists like Bridget Riley, with her geometric patterns in black and white, and M. C. Escher, with his eye-fooling illusions, that come to most minds first. In the fashion world, designers like André Courreges, Rudi Gernreich, and Paco Rabanne used the concepts of op art to create eye-catching, futuristic-looking garments.

A Day-Glo colors supplied the bright hues to keep the "Pucci-esque" look hot, vibrant, and plentiful.

A

There is Nobility in Fashion

Perhaps the most enduring designer to combine art and fashion was Emilio Pucci. Born into Italian nobility, the Marchese Emilio Pucci de Barsento lived the charmed life of a jet-setter. Like any jet-setter worthy of the title, the Marchese was an accomplished skier, even earning a place on the Italian Olympic ski team in 1934. It was as a member of the ski team for Reed College in the state of Oregon that he first tried his hand at designing clothes by creating the team's uniforms. The now legendary story goes that while Pucci was skiing in one of his own creations on the slopes of St. Moritz in Switzerland, *Harper's Bazaar* photographer Toni Frissell caught sight of the designs and brought photos of them back to the magazine's editor Diana Vreeland.

A delighted Vreeland asked Pucci to design a small line of ski clothing that could be sold in the United States. When department store Lord & Taylor bought Pucci's line, it propelled him into the forefront of fashion for decades to come—and earned him a place in his lineage as the first Pucci in a thousand years to work! A Pucci garment could command prices worthy of a socialite (or, well, of a Pucci)—and still do. Today, genuine vintage Pucci is high in demand, and if you are lucky enough to purchase one, your last name just might be Hilton.

A

©1970 Montgomery Ward

A Mercy momma! Palazzo pants or sideshow tent? Only her fashion designer knows for sure.

B Thirty-plus years later, pop art and op art are synonymous in many people's minds. In fact, the two are vastly different. Pop art exploits commercialism and consumerism, while op art makes use of illusion as its subject.

C The Marchese Emilio Pucci de Barsento created eye-catching designs and incorporated them into exquisite pieces of high-fashion art. This stunning 1970s Pucci gown shows why many copied him, but few matched him.

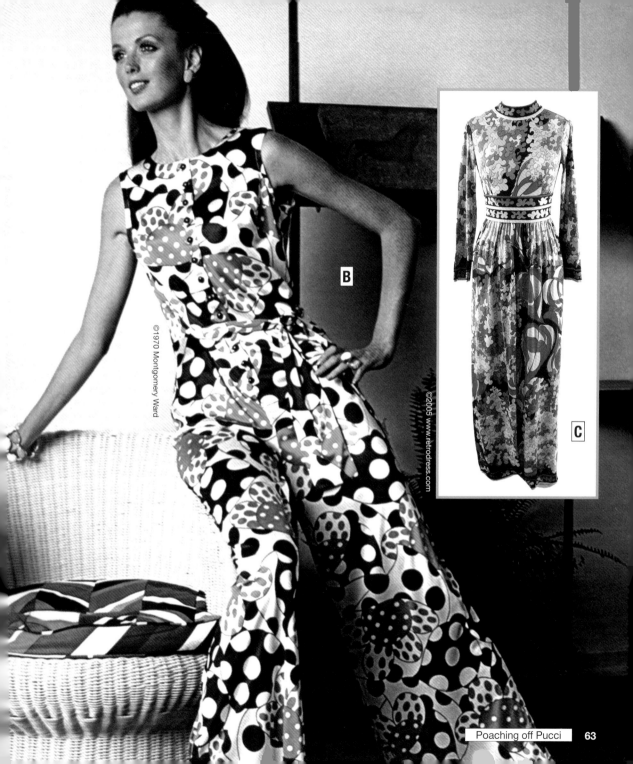

©1970 Montgomery Ward

B

C

©2005 www.retrodress.com

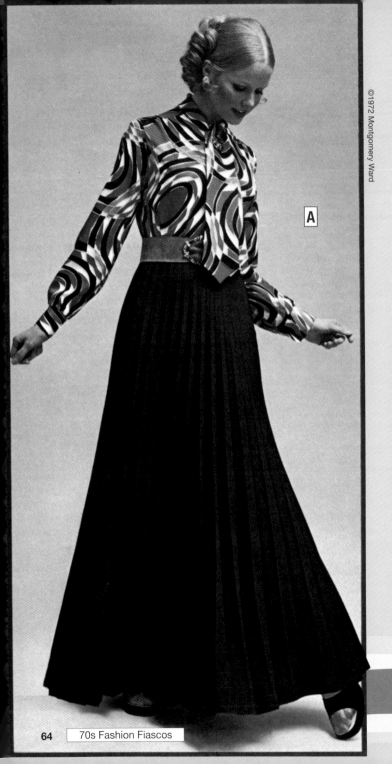

©1972 Montgomery Ward

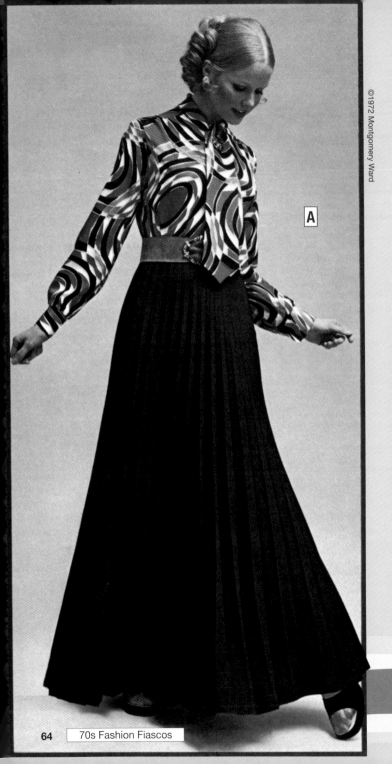
A

A Women's fashions often imitate men's, as in this ultra-wide tie on a colorful op-art-print dress.

B By the end of the decade, the op art look in clothing came down to just a few stray geometric shapes on the occasional garment. Like the op art movement itself, the clothing trend lasted only a few short years.

Trivia!

In April 1977 the glitter set had a new home for flash, cash, and fashion. Eight thousand invitations welcomed the beautiful people to attend the grand opening of an exclusive new discotheque, Studio 54, on Manhattan's west side. Eagerly accepting the invites were high profile celebs of the day such as Cher, esteemed writer Tennessee Williams, supermodel Margaux Hemmingway, designer Charles James, and royalty from all over the world. During its reign, Studio 54 was known for its outlandish extravagances of drugs, sex, and disco. Regulars frequently included designer Halston, Bianca Jagger, Andy Warhol, Liza Minnelli, and Truman Capote. The debauchery that was Studio 54 came to an end in 1986 when changing times left the hedonistic club behind.

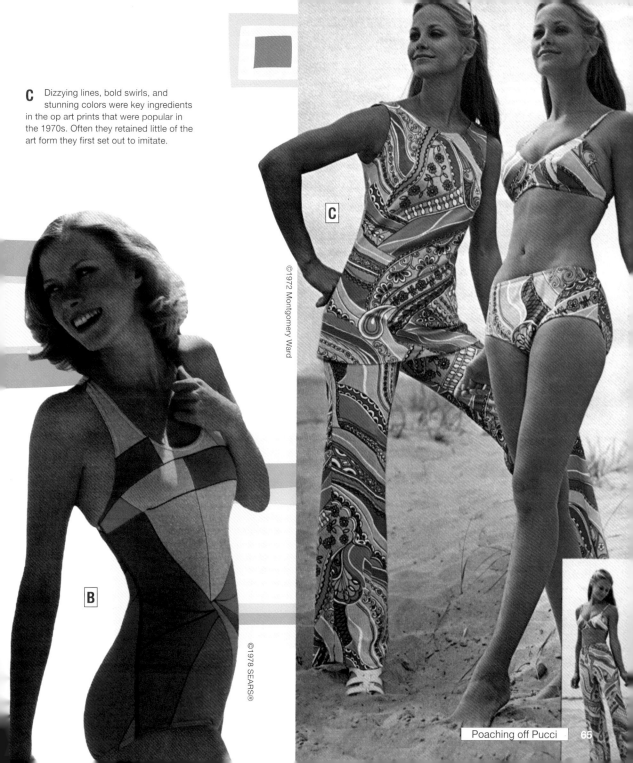

C Dizzying lines, bold swirls, and stunning colors were key ingredients in the op art prints that were popular in the 1970s. Often they retained little of the art form they first set out to imitate.

©1972 Montgomery Ward

©1978 SEARS®

Poaching off Pucci

Pucci in Flight

During the course of his illustrious career, Pucci created unmistakable (and unforgettable) prints using a combination of vivid colors and geometric shapes. His innovative work propelled textile design forward and helped change the face of fashion. His line continually expanded, running the gamut of women's clothing, perfume, linens, stationery, lingerie, and rugs. If you happened to live near a branch of the First National City Bank, you could score yourself a genuine Pucci checkbook cover— but only if you enrolled in the bank's combo plan of a low-cost checking account, savings account, and standby revolving credit.

Labeled a Renaissance man, Pucci didn't limit himself to earthly objects. In 1971, Apollo 15 astronauts David Scott, Alfred Worden, and James Irwin wore on their space suits red-white-and-blue Apollo 15 emblems designed by the couturier. If the earth-bound fashionists felt a bit of jealousy, they would be soothed in 1976 when the Emilio Pucci edition of the Lincoln Continental Mark IV rolled onto auto showroom floors. The Pucci edition sported a wine-colored body (appropriately called *Chianti*) with a matching "leather-like" interior and a silver roof. Because status is sometimes achieved only with a logo, the vehicle's rear oval windows filled the bill—the Pucci logo was emblazoned directly onto the glass.

A

©1972 Aldens, Inc.

A No longer simply your granny's white cotton bloomers, even undergarments jumped on the abstract-art bandwagon.

B Op art and flower power combine to create an eye-numbing dress in Easter pastels.

Trivia!

This Princess Leia 'do made its debut in 1972—a full five years before Star Wars even hit the big screen. A functional hairstyle, it was coifed to keep the wearer's ears warm without the need for cumbersome earmuffs.

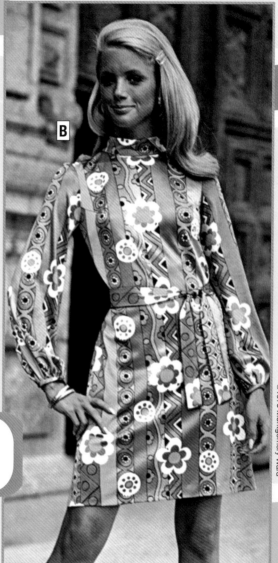

B

How Much Is That Pucci in the Window?

For those without a trust fund, department store retailers did their best to placate the masses with makeshift substitutes. "Pucci-esque" fashions were everywhere and on everything. If women couldn't afford the real thing, anything close would have to do. While a real Pucci could be made of the finest silk jersey or shimmering cotton satin, most women had to settle for stretch Dacron polyester knits.

(In some cases, "close" isn't close at all.)

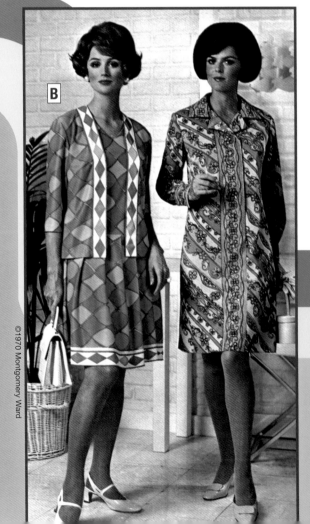

A

©1972 Montgomery Ward

B

©1970 Montgomery Ward

A The cut of the dress says conservative, but the mind-numbing, liquid-hot colors and over-the-top print tell a different story.

B Ladies who lunch deserve to be fashionable too. Decked out in their Wednesday finest, they catch a quick nibble at the club, and then they're off to the PTA meeting.

C Polyester pants outfits were just one of the many choices available to women in the 1970s. The bright colors and dynamic op-art print here said this woman was stylish, modern, and on the go.

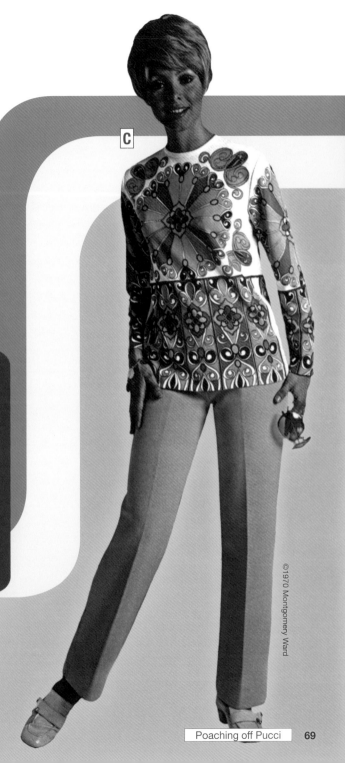

C

©1970 Montgomery Ward

Trivia!

Shag: that wildly popular, thick-pile carpet that graced homes across America in the 1970s. Shag: that impossible-to-keep-groomed, always-losing-stuff-in, rainbow-bright wonder. Shag: that absorbed-like-a-sponge, matted-when-wet, lint-producing floor covering.

Did it really belong in the bathroom?

CHAPTER
SIX

America Breaks a Leg
Platform Shoes Deliver
Thrills, Chills, and Plenty
o' Spills

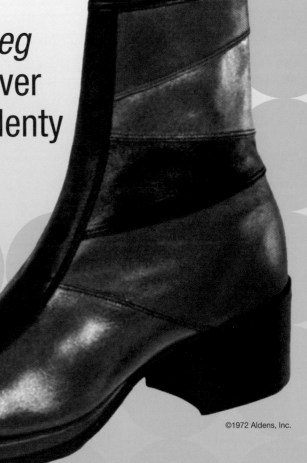

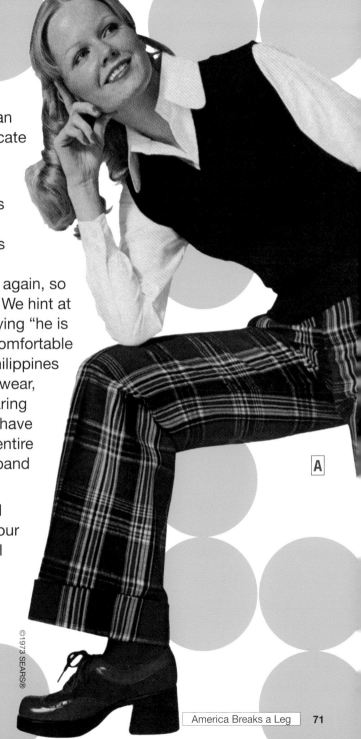

From a practical standpoint, shoes are nothing more than protective gear for the delicate bones in the feet. That, however, is far from the whole picture.

Shoes have long served as symbols and metaphors throughout society. Wearing shoes by today's designers Manolo Blahnik and Jimmy Choo displays your financial status. Then again, so does wearing a pair of Air Jordans. We hint at a person's sexual orientation by saying "he is light in the loafers" or "she wears comfortable shoes." Former First Lady of the Philippines Imelda Marcos, obsessed with footwear, reportedly owning 3,000 pairs. Wearing one pair a day, Mrs. Marcos would have taken 8.2 years to get through her entire collection—providing she didn't expand her stockpile along the way.

In the 1970s, shoe designers raised the stakes in their quest to control our soles—and we, the lemmings for all things hip and cool, happily stumbled along.

A

©1973 SEARS®

A There was never a shortage of platform styles and colors to match any mood or outfit.

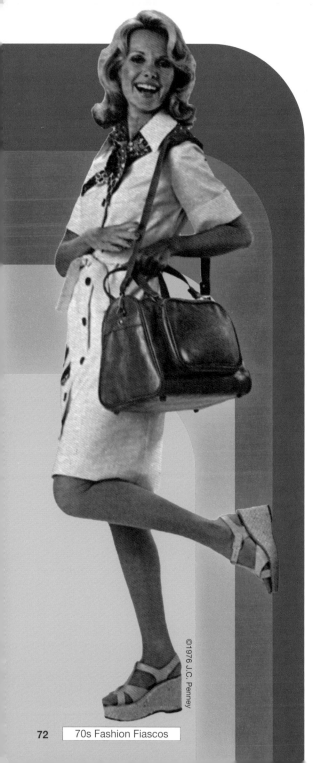

Clunky, Funky, and Chunky

To bring back the nostalgic romanticism of the 1940s, designers reintroduced the platform shoe. But the new generation of platform shoe lacked everything that gave the platform of the 1940s glamour, femininity, charm, and sex appeal. What designers bestowed upon us instead were the redheaded stepchildren of Harpo, Groucho, and Chico: Clunky, Funky, and Chunky. American women were shod in little more than 4 x 4-inch blocks of wood with leather straps attached to keep them from falling off…barely.

Perched on an average of three to five inches above the ground, women teetered and tottered to the fashion beat. Newspapers and magazines proclaimed the new creations imaginative, inventive, and dazzling (after all, advertising space must be sold). Fashion-conscious shoppers shuffled up to cash registers to purchase the towering soled impediments that ranged in price from $7.99 to $55 for a red T-strap platform with a yellow grosgrain bow on the heel, custom-ordered from luxe shoemaker I. Miller.

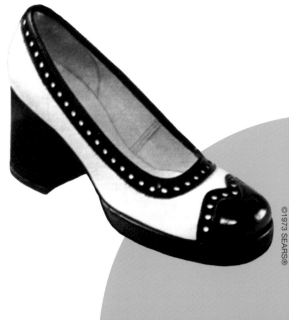

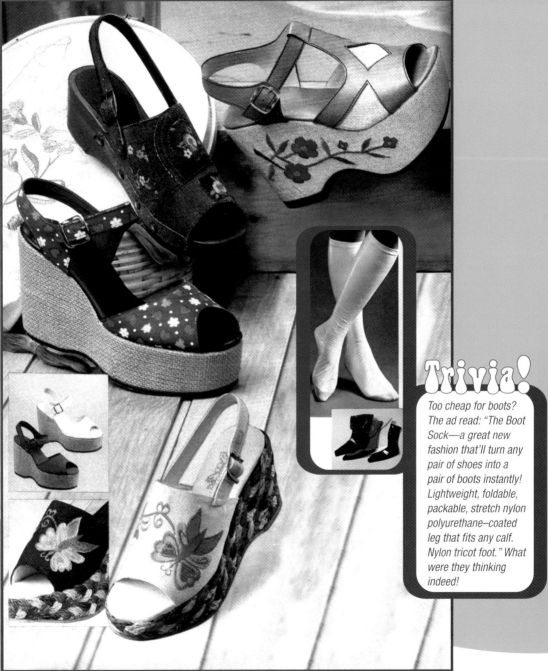

Trivia!

Too cheap for boots? The ad read: "The Boot Sock—a great new fashion that'll turn any pair of shoes into a pair of boots instantly! Lightweight, foldable, packable, stretch nylon polyurethane–coated leg that fits any calf. Nylon tricot foot." What were they thinking indeed!

Footnote or Foothold?

Serious fashion watchers proclaimed the mega shoe a fad and gaily sat back to watch the parade hobble by. But the fad, which began in Europe in 1969 and moved to the United States in 1970, showed no sign of slowing down. As the 1970s progressed, so did the platform's popularity and variety. For the younger (and the wannabe young again) crowd, summertime sandals were concocted mixtures of cork and jute, wood and leather, rubber and ribbon saddles with two-inch platform soles balancing on three-inch square heels. Because cork had been used in the 1930s and '40s for beach sandals, fashion pundits heralded the new cork platforms a fashion "revival." Big, thick four-inch clog-style soles of Frankenstein proportions were fabulous for beachcombing if you had a fear of getting your feet wet in the surf. (They also doubled as a flotation device in the event you were swept out to sea.)

Fashion designers perpetuated the melee by pitching their hats into the ring. In 1971, Christian Dior contributed a black satin evening shoe complete with rhinestones rimming the platform sole. Emanuel Ungaro went the Carmen Miranda route and sprinkled his towering patent-leather platforms with shiny little cherries. Few design houses stayed out of the platform's grasp, with the exception of society favorite David Evins, who, while not abstaining from platforms, designed them less obvious and more suited for a woman of elegance. Evins' explanation for the popularity of the outrageously stacked shoe: "Tell a woman they cause her to break an ankle but that they make her look 10 years younger, and she'll still wear them."

A

©1972 Aldens, Inc.

A The platform fad was heralded as imaginative and inventive, causing fashion followers to rush to their local retailers in droves, snatching up the statuesque soles by the bushel.

B Physicians found a lucrative career in treating injuries from the excesses of platform shoes in the 1970s.

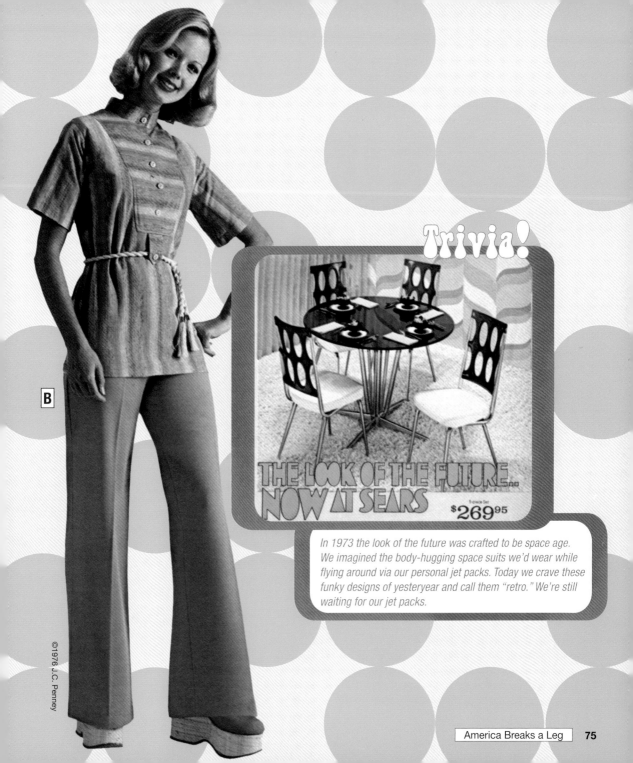

B

Trivia!

THE LOOK OF THE FUTURE...
NOW AT SEARS

5-piece Set
$269⁹⁵

In 1973 the look of the future was crafted to be space age. We imagined the body-hugging space suits we'd wear while flying around via our personal jet packs. Today we crave these funky designs of yesteryear and call them "retro." We're still waiting for our jet packs.

COLOR IMPACT

©1973 SEARS®

A

Sole Man

Not to be left behind for the ball, men put their best foot forward and gladly accepted a glass slipper of their own. The men's version of the platform shoe ran the gamut of wild two-tone shades. Gone were the boring, basic, black and brown oxfords. In their place were thick-soled, three- to four-inch-heeled eccentric monster shoes. It wasn't uncommon to see men sporting the high-heeled divinities in gold and silver, pink and purple, or green and yellow. Even a stiff price tag of up to $85 didn't deter fans. Baffled shoemakers soon learned that the freakier the shoe and the higher the heel, the better it sold.

The young men buying the ornate shoes insisted it had little to do with trying to appear taller. Instead, men seemed to gravitate toward the heightened soles for the macho swagger the lifted heels provided. Think of the swooning caused by John Travolta's *Saturday Night Fever* strut, and it's understandable that men would want to follow suit. Ladies have always loved a good swagger, and a man in platform heels could deliver.

Trivia!

The 1970s TV male cops provided plenty of smooth talk and fast action to match their fine duds: Starsky & Hutch *(Paul Michael Glaser and David Soul),* The Rookies, *(Georg Stanford Brown, Michael Ontkean, and Sam Melville), and* The Streets of San Francisco *(Michael Douglas and Karl Malden).*

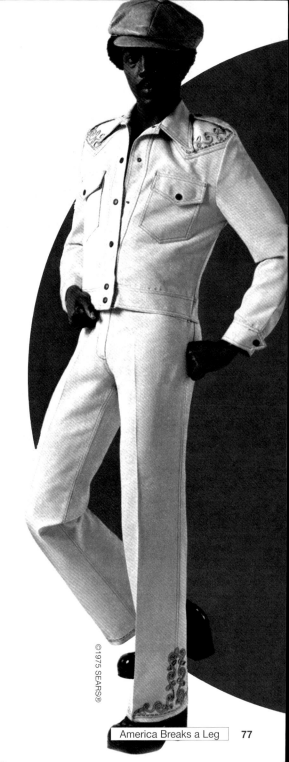

A Two-tone oxfords were hugely popular for both women and men. The chunky funky shoes could be worn with jeans, pantsuits, or dresses for gals and leisure suits or jeans for guys.

B Making the club scene in only the coolest of threads was rule one. Rule two? Don't let the man get you down.

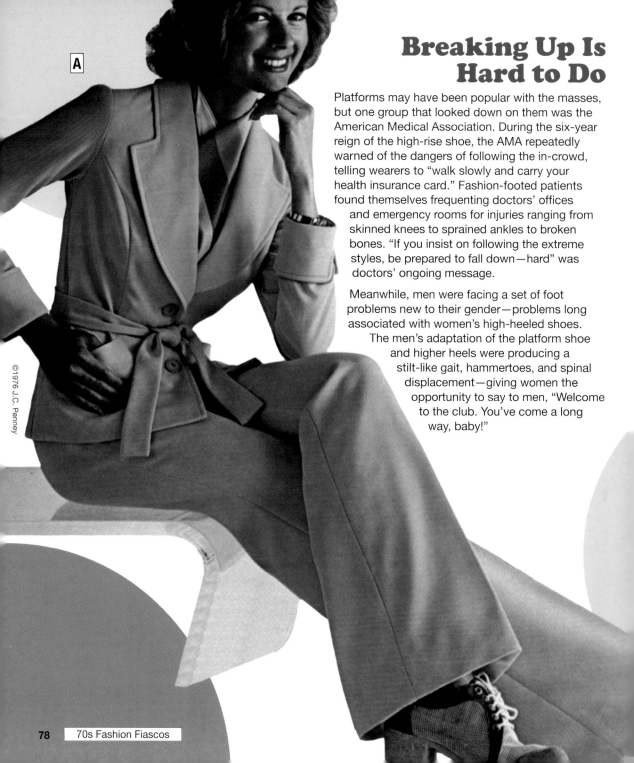

Breaking Up Is Hard to Do

Platforms may have been popular with the masses, but one group that looked down on them was the American Medical Association. During the six-year reign of the high-rise shoe, the AMA repeatedly warned of the dangers of following the in-crowd, telling wearers to "walk slowly and carry your health insurance card." Fashion-footed patients found themselves frequenting doctors' offices and emergency rooms for injuries ranging from skinned knees to sprained ankles to broken bones. "If you insist on following the extreme styles, be prepared to fall down—hard" was doctors' ongoing message.

Meanwhile, men were facing a set of foot problems new to their gender—problems long associated with women's high-heeled shoes. The men's adaptation of the platform shoe and higher heels were producing a stilt-like gait, hammertoes, and spinal displacement—giving women the opportunity to say to men, "Welcome to the club. You've come a long way, baby!"

Come on up to PLATFORMS
14.⁹⁸ pair

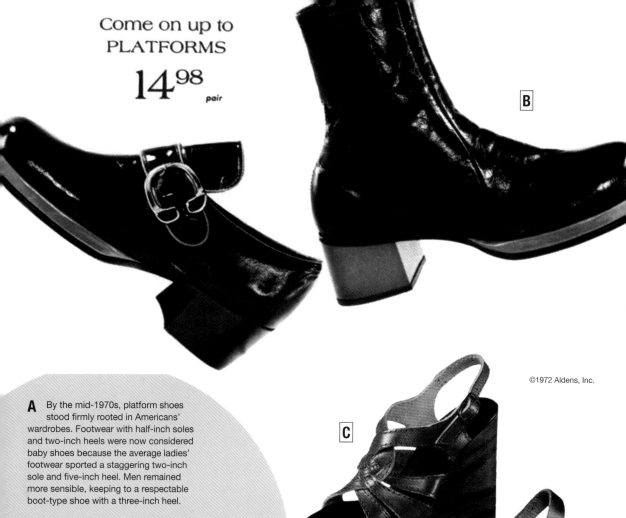

A By the mid-1970s, platform shoes stood firmly rooted in Americans' wardrobes. Footwear with half-inch soles and two-inch heels were now considered baby shoes because the average ladies' footwear sported a staggering two-inch sole and five-inch heel. Men remained more sensible, keeping to a respectable boot-type shoe with a three-inch heel.

B Men were not immune to the heights of the platform craze. Short men sought the dizzying heights with great glee, not taking into account that they would still be just as short. After all, the women they sought to reach had platforms of their own!

C Platform shoes can be traced back to Ancient Greece circa 450 BC. But while the originals where made with soft, level cork—platforms such as these, with their elevated heels and hard wooden blocks, would have been enough to make Athena cry.

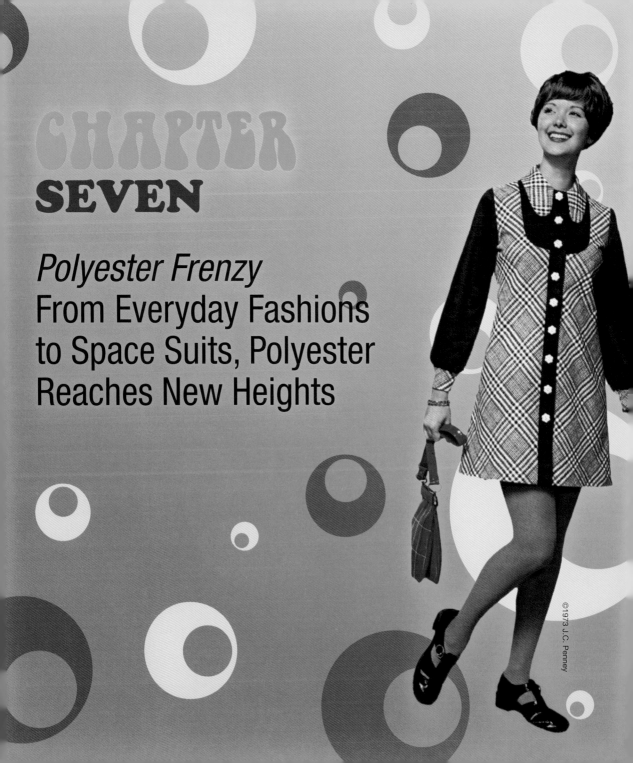

CHAPTER
SEVEN

Polyester Frenzy
From Everyday Fashions to Space Suits, Polyester Reaches New Heights

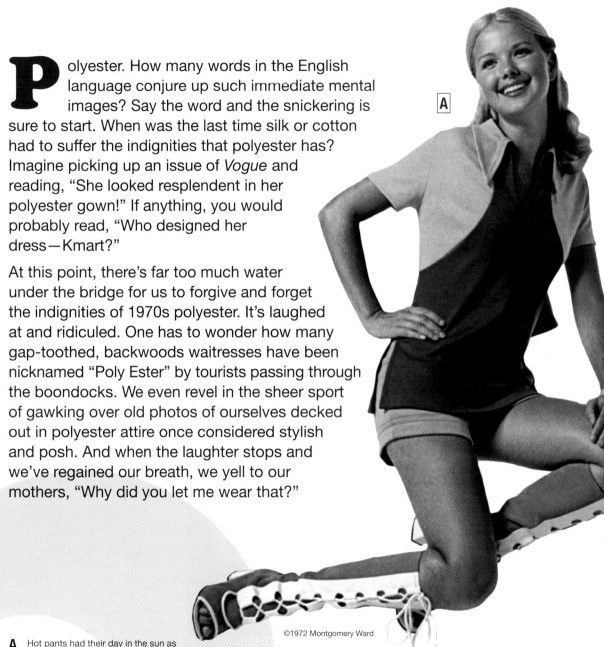

P olyester. How many words in the English language conjure up such immediate mental images? Say the word and the snickering is A sure to start. When was the last time silk or cotton had to suffer the indignities that polyester has? Imagine picking up an issue of *Vogue* and reading, "She looked resplendent in her polyester gown!" If anything, you would probably read, "Who designed her dress—Kmart?"

At this point, there's far too much water under the bridge for us to forgive and forget the indignities of 1970s polyester. It's laughed at and ridiculed. One has to wonder how many gap-toothed, backwoods waitresses have been nicknamed "Poly Ester" by tourists passing through the boondocks. We even revel in the sheer sport of gawking over old photos of ourselves decked out in polyester attire once considered stylish and posh. And when the laughter stops and we've regained our breath, we yell to our mothers, "Why did you let me wear that?"

©1972 Montgomery Ward

A Hot pants had their day in the sun as those sexy, short shorts best left to the young and fit.

In the Beginning...

The basis of polyester was first formed in 1929 when scientist Wallace Carothers discovered that mixing alcohols and carboxyl acids could produce fibers. The compound that became polyester, however, was quickly put on a back burner as Carothers turned his attention to an equally revolutionary formula—the one that produced the nylon fiber. It would be another 10 years before the polyester compound would be touched again, this time by a group of British scientists who picked up where Carothers left off. Working for England's Imperial Chemical Industries, they produced the first polyester fiber, Terylene.

In 1945, the American chemical giant DuPont purchased the rights to the research, and under its auspices, produced the second polyester fiber in 1950—the widely used Dacron, which was formally introduced to the American public in 1951. DuPont boasted that a polyester garment could be worn for 68 days straight without the need for ironing. The "wash and wear" line of fabrics was soon expanded to include Kodel polyester (made by Eastman Kodak), acrylic, and nylon. The invention of polyester would, for better or worse, change the clothing industry forever.

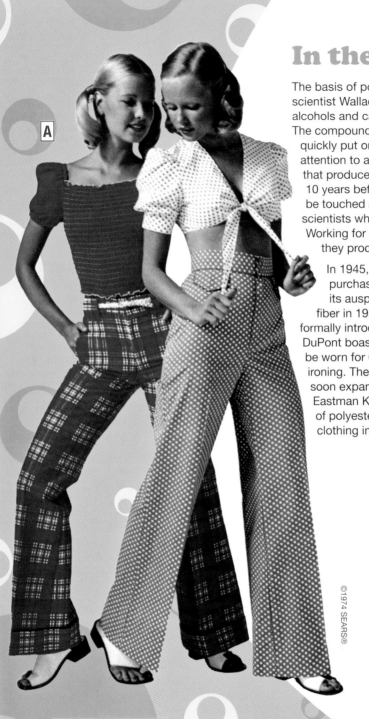

A

©1974 SEARS®

A Polyester blends in cute, girlie styles made date and play clothes fun and sexy, yet sweet.

B In a variety of polyester flavors, standard-issue dresses such as these could be found in every junior's closet. They worked great for school, dates, informal outings, work—just about anything a teen was into.

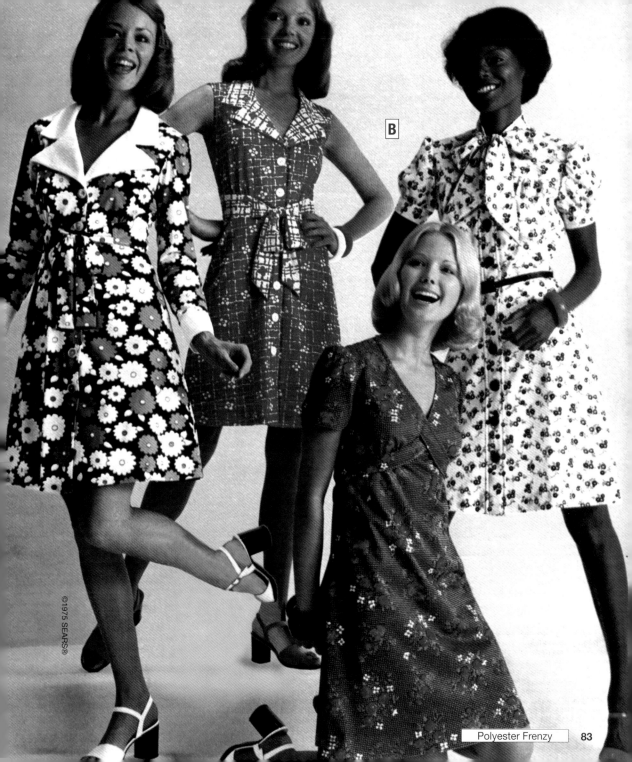

B

A

To the Moon!

By the mid-1960s, polyester was providing 40 percent of the nation's fiber needs. Everybody loved the fabric for its easy-care properties. It was durable, machine washable, quick to dry, and resistant to wrinkles, shrinkage, and stretching.

NASA, the U.S. space program, looked to polyester as the special fiber for use in astronauts' clothing—even for the nose cone of the spaceship itself. When Neil Armstrong set foot on the moon in 1969 and uttered the line that resounded around the world, "One small step for man, one giant leap for mankind," polyester was there in the space suit he wore.

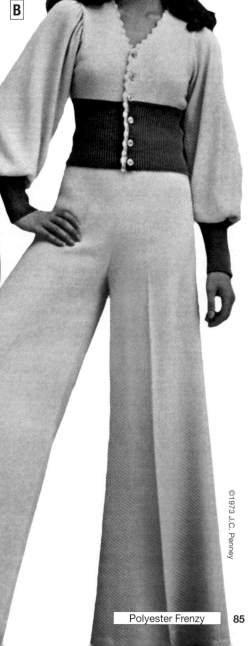

B

Trivia!

Leave it to the French to devise a test to determine if you could go braless. The test: place a pencil under your bosom. If the pencil fell, you could go braless. If it stayed? Don't burn your bra; you're going to need it. (Standing on your head or jumping up and down are forms of cheating.)

A Resplendent in their Dacron mini dresses, pointy bras, and helmet hairdos, these 1970 party girls had yet to be touched by the women's liberation movement.

B She would have been the class sweetheart in yards of flowing, ultra-feminine, ultra-pink polyester pants, with matching crop top.

©1973 J.C. Penney

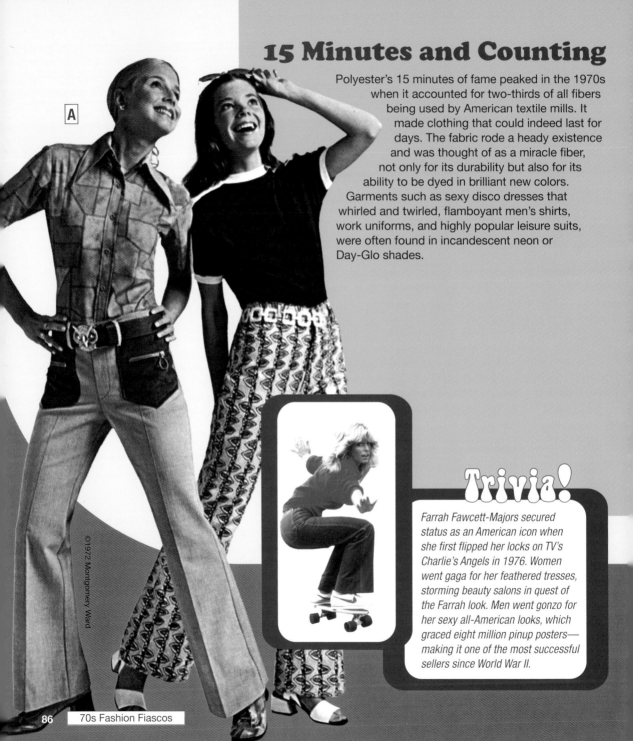

15 Minutes and Counting

Polyester's 15 minutes of fame peaked in the 1970s when it accounted for two-thirds of all fibers being used by American textile mills. It made clothing that could indeed last for days. The fabric rode a heady existence and was thought of as a miracle fiber, not only for its durability but also for its ability to be dyed in brilliant new colors. Garments such as sexy disco dresses that whirled and twirled, flamboyant men's shirts, work uniforms, and highly popular leisure suits, were often found in incandescent neon or Day-Glo shades.

A

©1972 Montgomery Ward

Trivia!

Farrah Fawcett-Majors secured status as an American icon when she first flipped her locks on TV's Charlie's Angels in 1976. Women went gaga for her feathered tresses, storming beauty salons in quest of the Farrah look. Men went gonzo for her sexy all-American looks, which graced eight million pinup posters—making it one of the most successful sellers since World War II.

The Times They Are a-Changin'

After sitting on top of the world for most of the 1970s, polyester felt the pinch of the changing times and shifting mind-set. As the decade drew to a close, people began to look again to the natural fibers that had supplied the world for centuries before. The culture was changing and the very properties that had once made polyester a favorite now made it equally unpopular.

People didn't want clothing that clogged the earth; polyester's indestructibility made it taboo. When burned, instead of turning to ash as natural fibers do, polyester melts, creating a gooey mass. Aside from the environmental impacts, polyester came to be seen as an uncomfortable fiber that induced sweating and itching and stigmatized its wearer as low class. Although it did continue in use, primarily in blends, polyester's day as the reigning fabric of choice was over.

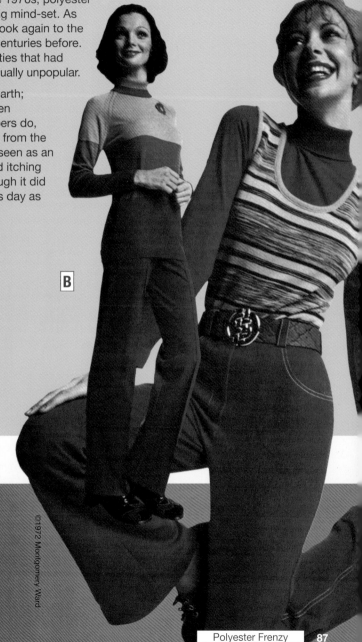

A Look! Up in the sky! It's a bird! It's a plane! It's Super Polyester coming down to reign havoc on all clothes pure and easy!

B Acrylic was a popular choice for clothing. With the shelf life of a Twinkie, acrylic can wear for decades. Maybe that's why 1970s vintage is so popular.

©1972 Montgomery Ward

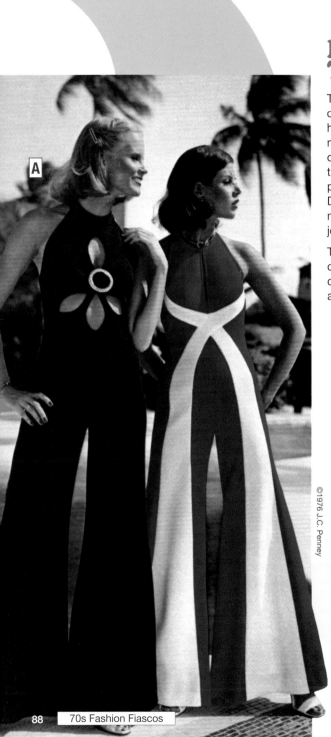

A

Hot and Trendy Again

Today polyester is enjoying a bit of the spotlight once again. Television shows like *That '70s Show* have thrust it back into the limelight with a whole new generation. Teens and young adults are clamoring for the once-trendy, then disgraced, now trendy again garments of yesteryear. Flamboyant polyester disco shirts are hip and cool to wear. Disco dresses fetch a pretty dollar on the vintage market. Even leisure suits, the butt of thousands of jokes, are hot, hot sellers.

The old adage, "What goes up must come down," could be rewritten to read, "What goes up must come down—until the next generation comes around."

©1976 J.C. Penney

A Elephant bell-bottom jumpsuits were hot in the mid-1970s, not only with fashionable women but with music icons as well. The most famous wearer of elaborate jumpsuits was the King, Elvis Presley.

B The fashion industry had a hard time letting go of the 1960s. Even in 1972 the styles still held fast to the 1960s swinging and mod looks that models like Twiggy made so popular

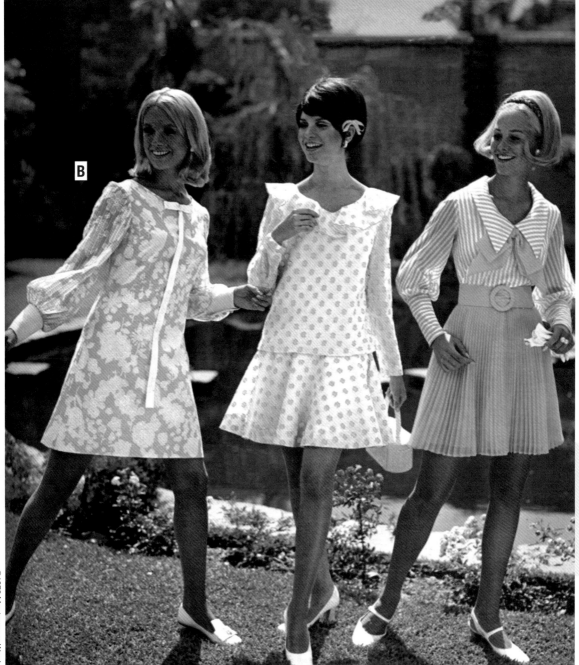

B

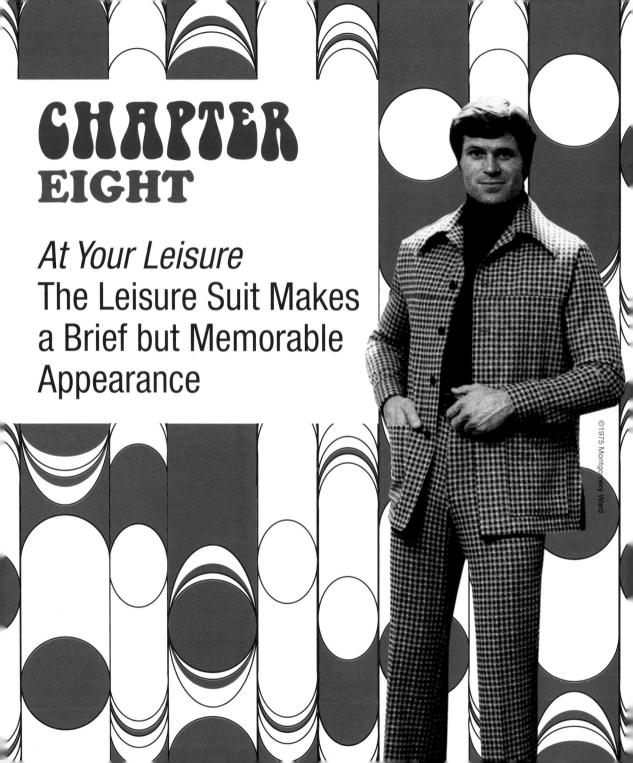

CHAPTER EIGHT

At Your Leisure
The Leisure Suit Makes
a Brief but Memorable
Appearance

I t started out innocently enough: fashion designers moving into the realm of men's clothing. It was a simple desire to liberate men from the stuffy suits that had dominated their wardrobes for decades on end. It was all just propelling fashion forward. No one was supposed to get hurt. No one was supposed to suffer. At least that's what they said.

A Early leisure suits consisted of tunic-length jackets that more closely resembled shirts. Much of the adornment was removed and the collars were elongated and ultra pointy. As for the colors, the door was wide open.

©1972 Montgomery Ward

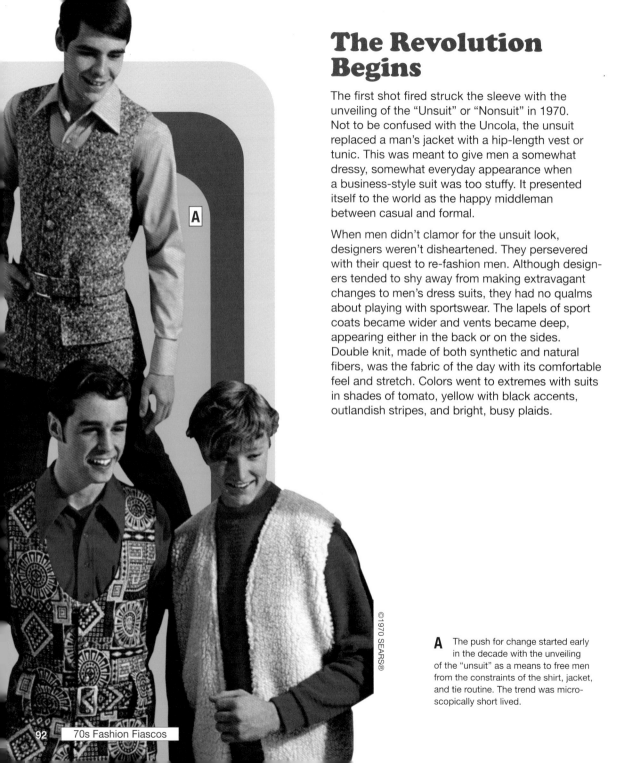

The Revolution Begins

The first shot fired struck the sleeve with the unveiling of the "Unsuit" or "Nonsuit" in 1970. Not to be confused with the Uncola, the unsuit replaced a man's jacket with a hip-length vest or tunic. This was meant to give men a somewhat dressy, somewhat everyday appearance when a business-style suit was too stuffy. It presented itself to the world as the happy middleman between casual and formal.

When men didn't clamor for the unsuit look, designers weren't disheartened. They persevered with their quest to re-fashion men. Although designers tended to shy away from making extravagant changes to men's dress suits, they had no qualms about playing with sportswear. The lapels of sport coats became wider and vents became deep, appearing either in the back or on the sides. Double knit, made of both synthetic and natural fibers, was the fabric of the day with its comfortable feel and stretch. Colors went to extremes with suits in shades of tomato, yellow with black accents, outlandish stripes, and bright, busy plaids.

©1970 SEARS®

A The push for change started early in the decade with the unveiling of the "unsuit" as a means to free men from the constraints of the shirt, jacket, and tie routine. The trend was microscopically short lived.

©1972 Mongtomery Ward

©1976 Mongtomery Ward

Hip to Be Square

The look most hip young people considered "square" was red hot with the over 25 crowd—and designers did their best to fan the flames. They put belts on tunic-length jackets that had been stripped of any other ornamentation. Traditional two- and three-button fronts were exchanged for those with zippers or snaps. Colors crossed the imaginary boundary of what previously had been acceptable for menswear. Shirt jackets now emerged in pastel tones of blue, green, and pink. Color became the key to individuality, and no shade was too effeminate for the 1970s man to wear.

By the mid-1970s the leisure suit could be found in a large variety of styles but the three most accepted were:

❄The Battle Jacket Suit or European Suit—This look lengthened the WWII Eisenhower jacket and added matching pants. It could be found in a variety of fabrics such as denim, twill, and of course, polyester. Its biggest following was among the younger, hipper crowd, who frequently sported the ensemble out on dates to the disco and other happening places.

❄The Shirt Suit—Using lightweight fabric to create slacks and shirt jackets, this look was popular for spring and summer. It came in a variety of patterns, stripes, solids, and everything in between. The shirt jacket was styled more after a shirt than a sport coat. It lacked lapels, and the collar tended to be long and pointed like a sport shirt.

❄The Safari Suit—Styled after traditional safari and hunting suits, this look was incredibly popular in both the city and suburbs. Manufacturers made it in a wide variety of fabrics and patterns, although the fabrics they selected were less coarse than those of suits one would wear on an actual safari. The urban safari suit outfitted the hunter of the great asphalt jungle whose only prey was the nine-to-five paycheck—and perhaps unsuspecting, polyester-clad disco divas.

In addition to providing us with hours of amusement (after all, who doesn't have a laughter-worthy photo of their leisure-suited father, brother, husband, or date), the main thing the suit did was sell…and sell, and sell. In 1974 alone, manufacturers were selling wholesale volumes of approximately $1.7 billion in leisure suits. At an average retail price of $79 to $100, that's a lot of leisure suits in the closet. Even America's commander in chief, President Gerald Ford, was known to wear bold, bright plaid leisure suits on trips to Camp David. No one was immune.

©1976 SEARS®

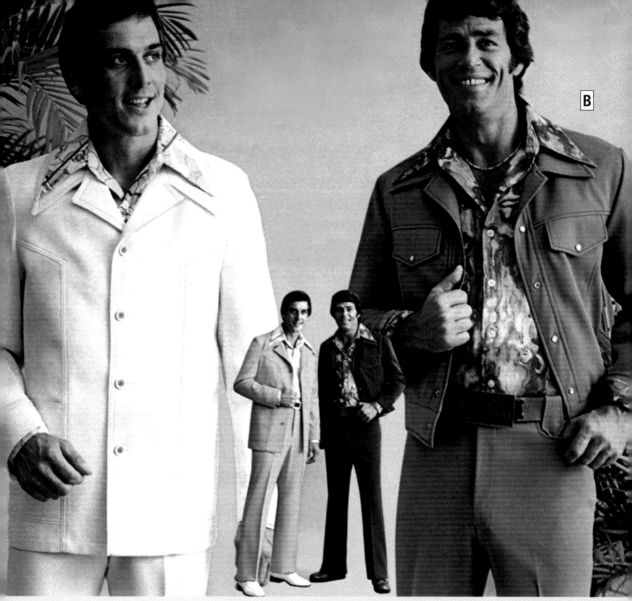

©1976 J.C. Penney

A The Battle Jacket Suit, also known as the European Suit, was most popular among younger men and the dating crowd. A twist on the old Eisenhower military jacket, it contained a dash of flash and a pinch of "now."

B 1970s style for men:
White buck shoes? ✓
Power print shirt and gold chain? ✓
Dynamite leisure suit guaranteed to make the ladies swoon? ✓✓
You are one fine ladies' man!

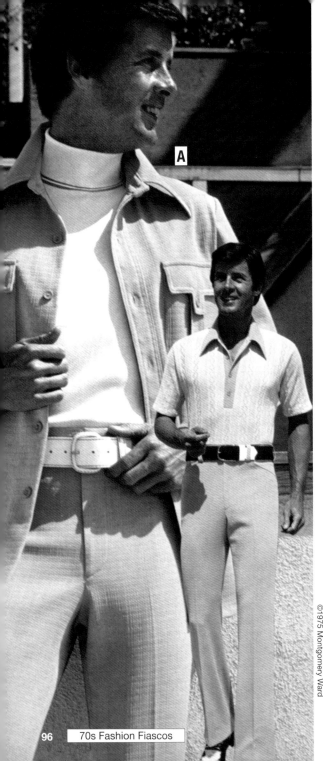

Leisure Suit or Lawsuit?

As popular as the leisure suit coup was, not everyone welcomed it with open arms. In California—a state know for its liberal atmosphere—a restaurant owner was sued for not allowing a patron in; the trendy fashionist was tieless and sporting a denim leisure suit! The jury deliberated for two days and, in the end, awarded the customer $75 for pain and suffering and $250 in statutory damages. The victory for the leisure suit, however, was not to be as sweet.

A The shirt suit used lightweight fabric to create shirt jackets and slacks. A popular look for spring, it was almost always guaranteed to be paired with a white belt and a pair of tropical white shoes.

B One of the most popular styles of the leisure suit was the safari suit. Designed after the traditional African bush suit, it used lighter-weight fabrics and a wider range of colors. This model was cut for summer and came with both long and short pants—chicken legs optional.

C The men of the 1970s wanted to not only look good but to smell good too. They routinely bathed themselves in colognes like Hai Karate, English Leather, Brut, Dunhill, Old Spice, and Aqua Velva, to name a few.

©1975 Montgomery Ward

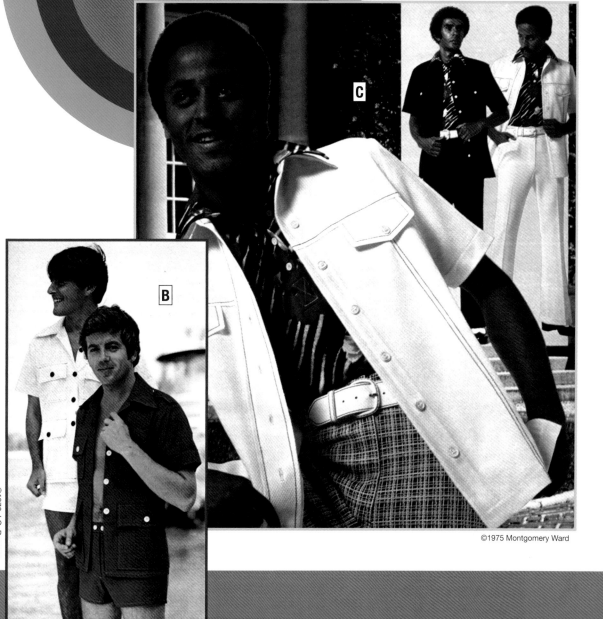

B

C

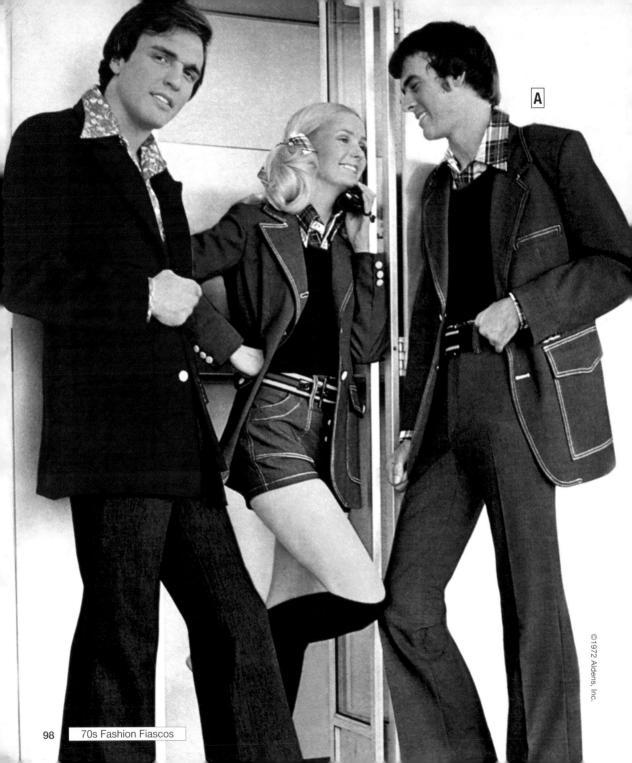

70s Fashion Fiascos

'Tis a Far, Far Better Thing

Once hailed by top designers John Weitz and Calvin Klein as a garment with staying power, the leisure suit was ostracized from the kingdom of *en vogue* before the 1970s even came to an end. Just as it had swiftly risen to the top of fashion, it fell into the leagues of comic relief twice as fast. Today we laugh at the cheesy styles, feminine colors, and garish plaids, and we even label the wearers as geeks. But what we seem to have forgotten is that the leisure suit did more than provide us with years of laughs. The leisure suit helped men open themselves up to new ideas in clothing. It allowed them to experiment outside of the style box they'd been locked in for too many years. If the 1970s had passed without the leisure suit, "business casual" for men might never have developed as soon as it did. The leisure suit may have been a fashion catastrophe, but it laid the groundwork for men to strut their fashion stuff for decades to come.

A The leisure suit was no place for the necktie. Men cast them aside with great aplomb as they experienced freedom of fashion never before afforded to them. Wild colors, mix and match, and funky shoes were only a part of this new found freedom.

B Transcending race and taste, the leisure suit was the garment of choice for any happening 1970s man. It was just as popular with the disco set as it was the jet set.

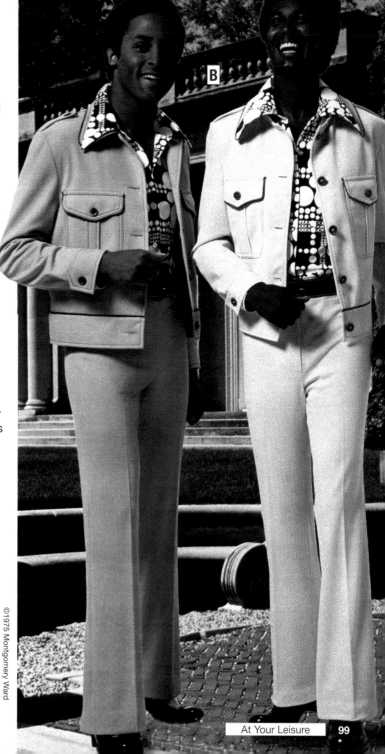

©1975 Montgomery Ward

SHOPPING RESOURCE

GUIDE

The Internet is a thriving metropolis and one of the best places to pursue your vintage interests. Most of the sellers listed here are people I've dealt with personally. Their garments and knowledge have placed them in this book, and their customer service and winning smiles have kept them on my pages! Others are here because of their outstanding reputations. All are worthy of your time and will provide you with a fabulous trip through the aisles and halls of all things vintage and retro.

Feel free to drop me an email with any of your vintage questions. I'm always happy to chat!

–Maureen

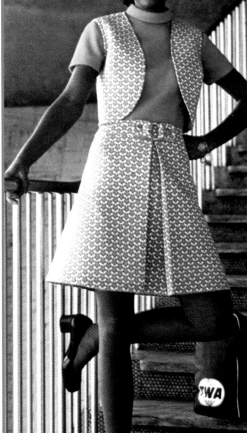

©1972 Mongromery Ward

Vintage Sellers

Maureen's website, Vintage Grace

vintagegrace.com

Wearable 1950s to 1980s vintage, from fun and funky to the elegant and romantic. Find everything, including retro housewares, retro clip art, vintage e-cards, and my weekly column, "Musings of Vintage Grace."

Email: maureen@vintagegrace.com

Affection4Vintage

babylonmall.com/format10.php?storenum=41

A fresh assortment from the 1940s to the 1980s, including wiggle dresses and men's vintage tuxedos.

eBay auctions: Search seller "FashionTales"

Email: pcameron@innernet.net

Another Time Antiques

anothertimeantiques.com

A unique shopping experience for vintage clothing, jewelry, textiles, and more treasures. Shop online or visit the New York shop.

Email: boycetime@aol.com

Phone: 585-538-9730

Location: 3164 State St., Caledonia, NY 14423

Babylon Mall

babylonmall.com

Vintage shopping nirvana with more than fifty shops specializing in vintage clothing and accessories.

Email: support@babylonmall.com

Contentment Farm Antique Textiles

contentmentfarm.com

From Victorian gowns to art deco-era lamé shawls to couture and designer pieces from the 1940s to today.

Email: info@contentmentfarm.com

Phone: 978-838-2235

Corsets and Crinolines

corsetsandcrinolines.com

Collectible clothing from bustles, boots, and bodices to petticoats and photographs.

Email: crinolinegirl@corsetsandcrinolines.com

Phone: +44 (0)11 6224 5361

Location: 29 Lansdowne Grove, Wigston, Leicestershire LE18 4LU, UK

Couture Allure

stores.ebay.com/Couture-Allure-Vintage-Fashion

Vintage clothing and accessories from the 1920s to the 1980s, including vintage dresses, suits, purses, hats, shoes, coats, furs, and more.

Debutante Clothing

debutanteclothing.com

A fiery boutique featuring classic little black dresses, mod, rockabilly, and designers from the 1940s to the 1980s.

eBay auctions: Search seller "oohthatscute"

Email: debutanteclothing@verizon.net

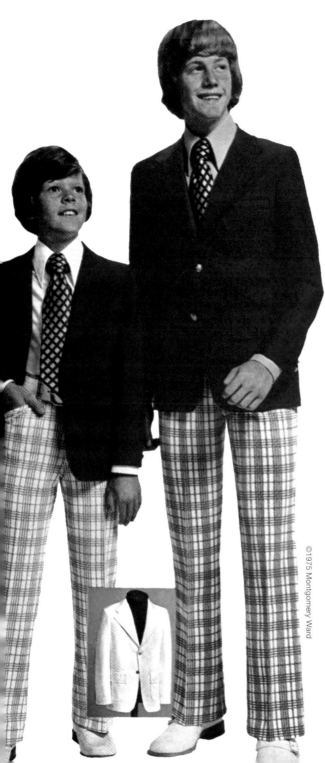

©1975 Montgomery Ward

Dress That Man

dressthatman.com

Built for men and specializing in 1970s fun and funky, such as crazy print polyester disco shirts, 1970s leisure suits, and more.

Email: dressthatman@gmail.com

Flashbak58

babylonmall.com/format11.php?storenum=77

Discriminating top-shelf selection makes this one of eBay's No. 1 vintage sellers.

eBay auctions: Search "flashbak58"

Email: flashbak58@aol.com

Frock of Ages

frockofages.com

Providing the South with fabulous quality vintage clothing and accessories since 1990.

Email: appointments@frockofages.com

Phone: 404-370-1006

Location: 1653B McLendon Ave., Atlanta, GA 30307

Jailhouse Frock

jailhousefrock.co.uk

Adorable clothing on an adorable website. Call it vintage shopping at its most comfortable!

Email: chris@jailhousefrock.co.uk

Phone: +44 (0)79 1353 9728

Material Memories

materialmemories.vc-mall.com

The most divine selection of vintage garments.

eBay auctions: Search seller "beardnlady"

Email: matrlmemry@aol.com

Memphis Vintage

memphisvintage.com

Longtime favorite carries designs by Pucci, Ceil Chapman, Gucci, Carolyn Schnurer, Malcolm Starr, and others.

eBay auctions: Search seller "memphisvintage"

Email: info@memphisvintage.com

Past Perfect Vintage

pastperfectvintage.com

Quality pieces from Victorian and Edwardian eras as well as the 1920s to the 1960s. View owner's gorgeous private-collection gallery.

Email: montyholly@insightbb.com

Posh Girl Vintage Clothing

poshgirlvintage.com

From couture to street style, this upscale vintage clothing boutique offers gorgeous garments from the 1920s to the 1980s.

Email: poshgirlvintage@pacbell.net

Retro Dress

retrodress.com

Everything is to die for, from stunning designer garb to heavenly accessories.

Email: info@retrodress.com

Phone: 619-443-4933

Sara's Attic

sarasattic.co.uk

The darling of the U.K. press has a funky and colorful assortment of everyday dresses and glitzy party frocks!

Email: sarasattic@msn.com

Vintage Hollywood

vintagehollywood.com

From Internet hub Port Halcyon comes loads of drool-worthy goodies from the 1930s to the 1970s, including killer 1940s platforms.

Email: joe@porthalcyon.com

Woo Vintage

woovintage.com

Located on the Web and in a Vancouver shop, with special sections for Asian fashions, day dresses, and formal wear.

Email: natalie@woovintage.com

Location: 321 Cambie St., Vancouver, BC, Canada

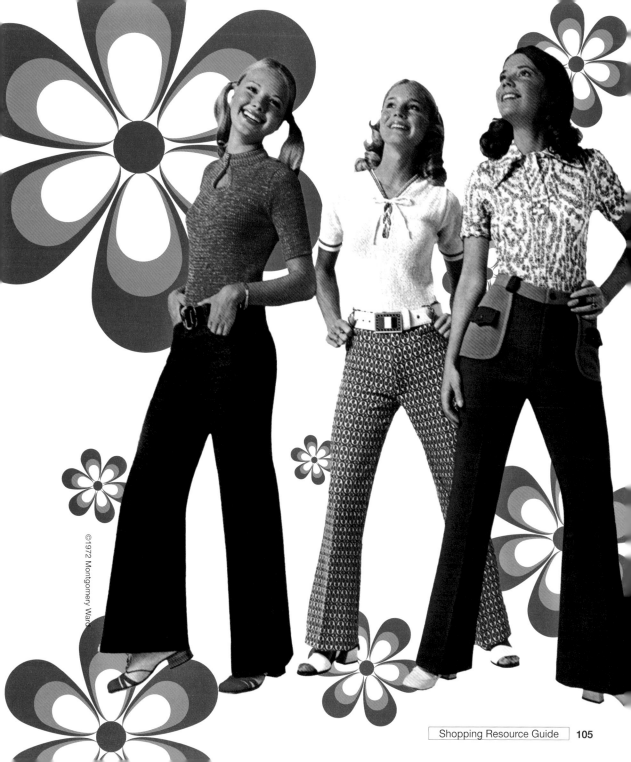

©1972 Montgomery Ward

Museums and Collections of Significant Interest

Bata Shoe Museum, Toronto

batashoemuseum.ca

This collection of 10,000 shoes includes Western fashion, Native American, celebrity shoes, and regularly rotating online exhibits.

Email: programs@batashoemuseum.ca

Phone: 416-979-7799

Location: 327 Bloor St. West,
Toronto, ON M5S 1W7, Canada

Cornell Costume and Textile Collection

human.cornell.edu/che/TXA/cctc.cfm

Collection includes 9,000 items of apparel dating from the eighteenth century to the present, including ethnographic textiles and costumes.

Email: caj7@cornell.edu

Location: Cornell University,
Martha Van Rensselaer Hall, Ithaca, NY 14850

Costume Institute, Metropolitan Museum of Art, New York

metmuseum.org/collections/department.asp?dep=8

About 80,000 costumes and accessories spanning five continents and centuries. Extensive reference library too.

Email: thecostumeinstitute@metmuseum.org

Phone: 212-570-3908

Location: 1000 Fifth Ave. at 82nd St.,
New York, NY 10028-0198

The Doris Stein Research Center for Costume and Textiles, Los Angeles County Museum of Art

collectionsonline.lacma.org

Fifty thousand pieces representing one hundred cultures and 2,000 years.

Email: dsc@lacma.org

Phone: 323-857-6085

Location: 5905 Wilshire Blvd.,
Los Angeles, CA 90036

The Hope B. McCormick Costume Center, Chicago Historical Society

chicagohs.org/collections/costume.html

Extensive 50,000-piece collection includes suits worn by George Washington and prominent Chicagoans, plus international designers.

Phone: 312-642-4600

Location: Clark Street at North Ave.,
Chicago, IL 60610-6071

June Mohler Fashion Library, Kent State University Museum

dept.kent.edu/museum/

American and European high fashion from the eighteenth century to the present.

Email: museum@kent.edu

Phone: 330-672-3450

Location: Kent State University, Rockwell Hall,
Kent, OH 44242-0001

Museum of the City of New York

mcny.org/collections/68.html

Twenty-five thousand garments and accessories, dating from the mid-eighteenth century to the present, capture the history of changing fashion tastes.

Email: research@mcny.org

Phone: 212-534-1672, ext. 3399

Location: 1220 Fifth Ave.,
New York, NY 10029

Museum of Costume, Bath

museumofcostume.co.uk

Four hundred years of fashion, from the late sixteenth century to the present day.

Email: costume_enquiries@bathnes.gov.uk

Phone: +44 (0)12 2547 7173

Location: Museum of Costume, Bennett St.,
Bath BA1 2QH, UK

Philadelphia Museum of Art

philamuseum.org

Collection features costumes from the Middle East, Asia, Europe, and the United States.

Email: info@philamuseum.org

Phone: 215-763-8100

Location: 26th St. and the Benjamin Franklin Pkwy.,
Philadelphia, PA 19130

Shoe Icons Virtual Shoe Museum

eng.shoe-icons.com/index.htm

A stunning online collection from Moscow that's flush with information.

Email: mail@shoe-icons.com

Texas Fashion Collection

web2.unt.edu/tfc_test/main/Index.htm

Fifteen thousand items of historic dress, with an extensive online catalog.

Email: walker@unt.edu

Phone: 940-565-2732

Location: University of North Texas,
School of Visual Arts,
Denton, TX 76201

Victoria and Albert Museum, London

vam.ac.uk

Extensive collection of 63,000 fashionable dresses and textiles in addition to generous Web site resources.

Email: vanda@vam.ac.uk

Phone: +44 (0)20 7942 2000

Location: V&A South Kensington, Cromwell Rd.,
London SW7 2RL, UK

Just Plain Retro Fun

A Dress A Day

dressaday.com/dressaday.html

Hand-selected vintage dresses discussed with witty prose by blogger Erin McKean.

Email: erin@dressaday.com

All Dress Forms

alldressforms.com

Shop with Stephanie for amazing miniature dress forms and mannequins sporting adorable vintage garments.

Email: sales@alldressforms.com

Fashion-Era

fashion-era.com

More than 508 pages of rich fashion history and photos from 1750 to 2005.

Email: pauline@fashion-era.com

Fashion Trac

fashiontrac.com

Resource for the latest fashion news, analysis, and special features. The chat forum is a wealth of information!

Email: staff@fashiontrac.com

Lileks.com

lileks.com

Featuring The Institute of Official Cheer, where all things once serious resurface to be ridiculed in the most delightful way! Don't miss "The Dorcus Collection." Crying has never been this much fun.

Email: Lileks@mac.com

Port Halcyon

porthalcyon.com

This online town feeds your need for vintage music, fashion, culture, and lifestyle, with articles, reviews, shopping, and more.

Email: joe@porthalcyon.com

Retro Radar

retroradar.com

Mid-twentieth-century pop culture, including hot rodders, lindy hoppers, classic film, art deco, vintage clothing collectors, and more.

Email: comments@retroradar.com

Tack-O-Rama

tackorama.net

The best online emporium for retro clip art, from advertising to fashion, retro fonts, and lots more.

Email: tack.o.mail@gmail.com

World Wide Retro

worldwideretro.com

Home to rockabilly madness, Kustom Kulture, music, books, cool retro gear, and free, hot, retro clip art!

Location: 605 Main Street, Dearborn, MO 64439

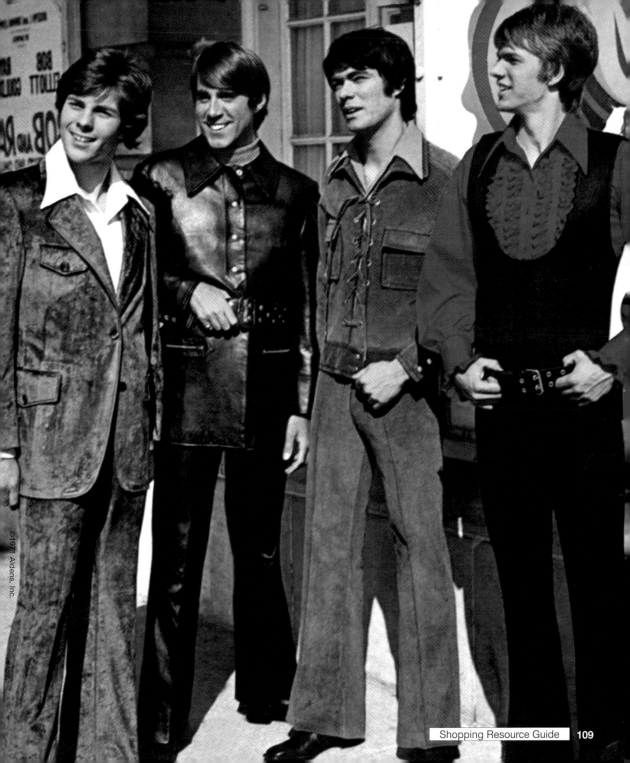

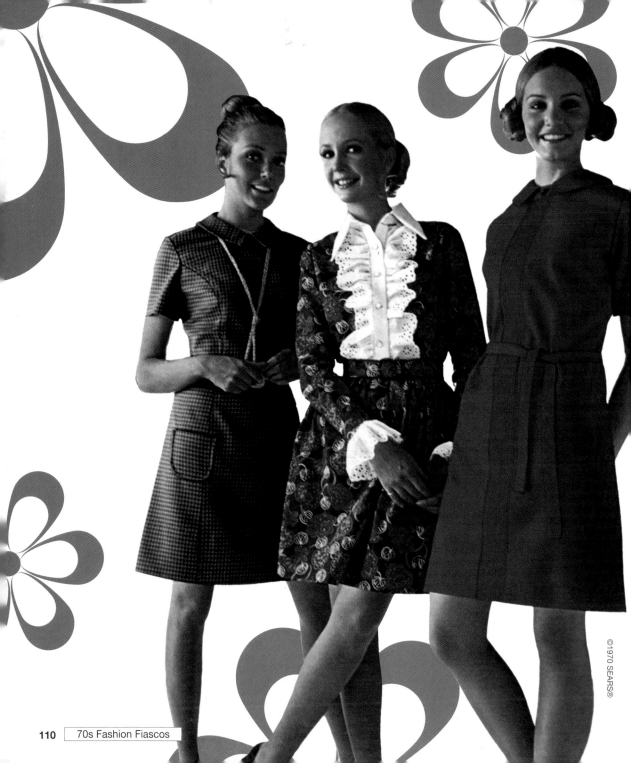

70s Fashion Fiascos

Selected Bibliography

Marylin Bender, "Pants-Ban Tempest at CBS," *New York Times*, January 21, 1970.

Julie Byrne, "Antidote to the High-Rise 'Klunks'," *Los Angeles Times*, December 3, 1972.

Judy Klemesrud, "What to Wear Is Special Problem for Women on Television," *New York Times*, February 9, 1970.

Marji Kunz, "Ties and Sexuality," *The Chicago Tribune*, March 18, 1973.

Jim Murray, "After His Fashion," *Los Angeles Times*, February 19, 1976.

UPI, "AMA Advice on High Shoes: Walk Slowly," *Los Angeles Times*, October 18, 1973.

Unknown, "The Scotch Connection in Style," *Los Angeles Times*, May 20, 1976.

Credits

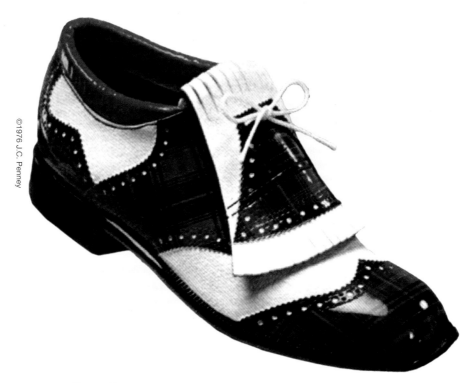

©1976 J.C. Penney

Acknowledegments

First and foremost, a very heartfelt thank you to the amazing Lindsay Brown, Managing Editor of Collectors Press, for her nerves of steel and patience of a saint. But most of all, for not giving up on this book or me. I can never say thank you loud enough or big enough. Also, thanks to my graphic designers Kevin Welsch and Devon Smith of Collectors Press for all their creative hard work. The book looks amazing thanks to you!

This book also couldn't have happened without an amazing group of friends and colleagues, cheering and prompting me on. Each and every one of them is a superstar: Susan Collier Ryals and Lisa "yellow chiffron" McSherry Matheson, who know me and love me in spite of myself; Candice Mitchell, who kept me company on many, many late nights; John W. Sammon (sammonsays.com), who's constant encouragement is immeasurable; Sandra Mendoza (debutanteclothing.com), for her words of wisdom that remain taped to my computer; the amazing Scott Jorgenson, for sharing his immense knowledge, showing me the tools of the trade, and of course, the commercial grade eunuchs; Dan Loefflebein, graphic designer magnifique', for coming to my rescue when I was drowning in a sea of images; Alan Ehrgott and the staff of the American River Conservancy (arconservancy.org), for allowing me the time and room to complete this project; to all those fabulous eBay sellers who keep my addiction to vintage catalogs and magazines well fed; and last but not least, to the amazing crew at my tiny Somerset U.S. Post Office, who schlep all those pounds of vintage catalogs and magazines for me but always have smiles on their faces—you guys are the best!